C000017872

TREASURES OF

# BRITISH ART

TATE GALLERY

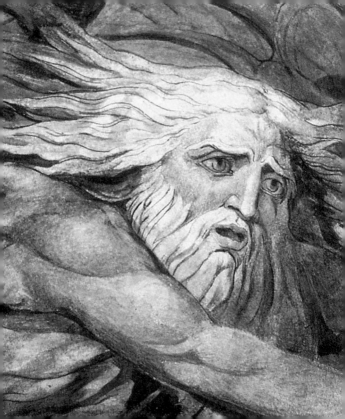

TREASURES OF

# BRITISH ART

TATE GALLERY

FOREWORD BY NICHOLAS SEROTA

TEXT BY ROBERT UPSTONE

A TINY FOLIO™
ABBEVILLE PRESS  PUBLISHERS
NEW YORK  LONDON

Front cover: Detail of Dante Gabriel Rossetti (1828–1882), *Proserpine*, 1874. Oil on canvas, 49¼ x 24 in. (125.1 x 61 cm).
Back cover: David Hockney (b. 1937), *A Bigger Splash*, 1967. Acrylic on cotton duck, 95½ x 96 in. (242.6 x 243.8 cm).
Spine: Henry Moore, *King and Queen*, 1952–53, cast 1957. See page 271.
Frontispiece: Detail of William Blake, *Elohim Creating Adam*, 1795/c. 1805. See page 107.
Page 6: Detail of Lucian Freud, OM, *Girl with a White Dog*, 1950–51. See page 279.
Page 8: Exterior of the main entrance.
Page 13: Exterior of the Clore Gallery.
Page 14: Detail of British School, *The Cholmondeley Ladies*, c. 1600–1610. See page 26.
Page 48: Detail of William Hogarth, *The Painter and His Pug*, 1745. See page 56.
Page 102: Detail of Joseph Mallord William Turner, *Snow Storm: Steam-Boat off a Harbour's Mouth*, exhibited 1842. See page 124.
Page 142: Detail of William Holman Hunt, *The Awakening Conscience*, 1853. See page 159.
Page 208: Detail of David Bomberg, *The Mud Bath*, 1914. See page 236.

For copyright and Cataloging-in-Publication Data, see page 319.

# CONTENTS

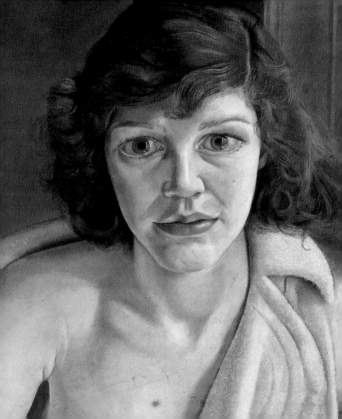

# FOREWORD

With its unrivalled collection of British art spanning five centuries, the Tate presents its visitors with a detailed survey of the national school while also offering a fascinating glimpse of the spirit and psyche of the British themselves—their tastes and preoccupations, predilections and prejudices. Artists in the past produced objects not just for their own satisfaction but also to strike a chord with collectors, patrons, and the public. Many traits are revealed, but the love of landscape is a consistent thread, often expressed with a haunting lyricism and passionate sense of involvement. Also evident is a fascination with conveying both physical appearance and psychological character in the painted portrait, as well as native wit and an occasionally ribald sense of humour. Other works display the British love of animals or attraction to the sea. This range of subjects reflects the rich diversity of British culture itself.

I hope this small book will give you an insight into the full variety and continuing excellence of British art. If you have not paid a visit to the Tate Gallery in London, Liverpool, or St. Ives, I hope it will whet your appetite to do so.

*Nicholas Serota*
*Director*

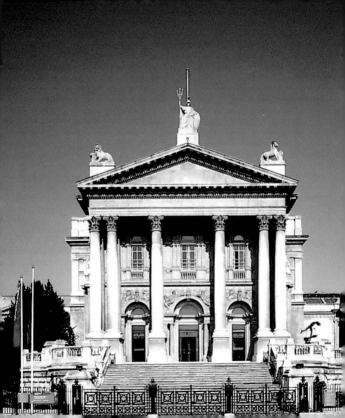

# INTRODUCTION

The Tate Gallery, while perhaps best known for its modern art, is responsible for the United Kingdom's collection of British art from the sixteenth century to the present day. This book offers a survey of some of the finest and most interesting of the British works, including paintings, watercolours, drawings, and sculpture of all periods, as well as a number of pieces constructed in recent decades from a wide variety of other media. Some of the artists represented here are familiar British masters with international reputations, such as William Blake and Joseph Mallord William Turner. Also to be discovered, however, are many outstanding works by artists who, unjustly, are less well known, especially abroad.

The Tate Gallery at Millbank currently shows British works in the same building as modern foreign art. However, with the opening at the turn of the century of the new Tate Gallery of Modern Art in the converted Bankside Power Station, a short distance down the Thames, Millbank will revert to its original conception as the Tate Gallery of British Art and will be able to offer a definitive overview and evaluation of the "British School."

The Tate Gallery has a short history compared to its elder cousins the National Gallery and the British

Museum. It was founded on an initial act of great generosity and philanthropy, and has continued to grow over the decades because of subsequent ones. The gallery, which was opened in the summer of 1897 by the Prince of Wales, took its name from its munificent benefactor, the sugar magnate Sir Henry Tate (1819–1899). Tate had risen from modest beginnings to build a fortune on refined sugar, and in particular the sugar cube. Not only did Henry Tate give his large collection of fine, mostly nineteenth-century British pictures to the nation, he also paid for the construction of an elegant neoclassical gallery to hold them. Designed by Sidney J. R. Smith, it was built on a site by the River Thames where the notorious Millbank Prison had stood before its demolition in 1892. Henry Tate believed in the power of art to educate and enrich the lives of those who had access to it, and the gallery has opened its doors to a large and appreciative audience ever since. As the founder's inscription in the building recorded, he also intended the gallery to be "for the encouragement of British Art and as a thank offering for a prosperous business career of sixty years."

For the new gallery's opening, Henry Tate's collection of sixty-five pictures and three pieces of sculpture was supplemented by British works of art transferred from the National Gallery and the South Kensington Museum (now the Victoria and Albert Museum). Along

with these came a number of pictures purchased previously for the nation with funds provided for that purpose by the endowment of the sculptor Sir Francis Chantrey. The works in the gallery from this variety of sources were predominantly nineteenth century.

Since 1897 the original building has been much added to, as have the collections. Henry Tate paid for an extension that was completed in 1899, and subsequent additions were funded by the art dealer Sir Joseph Duveen and his son. Throughout the twentieth century the collections have expanded in scope and increased in size, and the Tate now holds important collections of work by British masters of all periods.

The largest group of works by a single artist is by Joseph Mallord William Turner—nearly three hundred oils and several thousand drawings and watercolours. These were accepted by the nation from the artist's estate and are now housed in the purpose-built Clore Gallery, which opened in 1987 through the generous funding of the Clore Foundation. For the first time a fully representative selection of Turner's work in all media and all periods can be seen under a single roof, and this is a popular attraction for visitors.

In recent years twentieth-century British works have also been shown in the regional galleries that the Tate has opened in Liverpool and St. Ives. In addition, the new

policy of rehanging the collections in London each year has allowed the Tate to show a far greater range of its rich holdings, since the current space allows only a fifth of the collection to be exhibited at Millbank at any one time.

This book offers only a taste of the great variety of masterpieces of British art of all periods that can be seen at the Tate. It has been extremely hard to limit the number of artists and pictures included here, and many have been left out who in a fuller history should take their rightful place beside their peers.

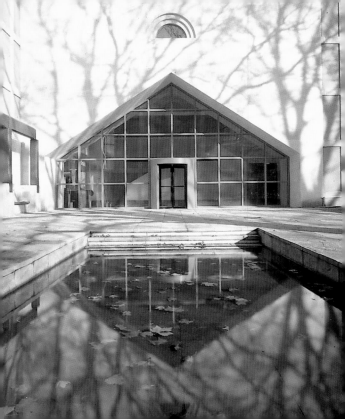

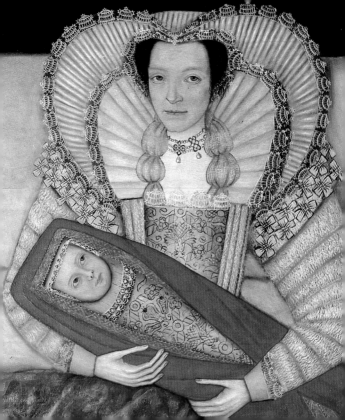

# THE SIXTEENTH AND
## SEVENTEENTH CENTURIES

The earliest works in the Tate Gallery date from the six-teenth century. Following Henry VIII's break with the Roman Catholic Church, native religious painting died out for a time and easel painting in Britain became devoted almost exclusively to portraiture. Henry's court painter was Hans Holbein the Younger, and it was one of his followers, John Bettes, who in 1545 painted what is the oldest picture in the Tate Gallery, a portrait of an unknown man in a black hat (page 17).

Portraiture endured as the mainstay of British art throughout the sixteenth and seventeenth centuries and beyond. Its most prestigious exponents in this early period were, in chronological order, Hans Eworth, Mar-cus Gheeraerts the Younger, Paul van Somer, Anthony Van Dyck, William Dobson, Peter Lely, and Godfrey Kneller. As their names suggest, apart from Dobson all these painters were born and trained abroad. However, they all lived in Britain at one time or another and achieved success and influence here; some of them were also rewarded with knighthoods. The Tate collection includes fine examples by all these masters, each of whom is represented in this survey.

The development of the British School's singular character in fact owed much to the influence of foreign painters. Despite their foreign birth the Tate classifies those in its collection as British artists, because of their residence and activity within these shores as well as their often profound impact on British painting. Indeed, the influence of foreign artists and schools has played a central role in Britain's art through the centuries. At different times and in greatly varying degrees the styles of Flanders, Holland, France, Germany, Spain, and Italy have all had influence, transmitted either through artists from these countries who came to live in Britain or through enthusiasm for these national styles by British artists and their patrons.

Seventeenth-century British portraiture developed away from the sharply focused, somewhat stylized, and often highly decorated images of the Elizabethan era towards a greater naturalism, albeit of a frequently contrived variety. Whereas Elizabethan representation was mainly concerned with documenting the sitter's rank and position within society and with recording physiognomy, works from the later period sought to convey the person's full character and inner life as well. William Dobson's portrait of Endymion Porter (page 36), for instance, shows the sitter surrounded by visual allusions to his enthusiasm for the arts and his knowledge

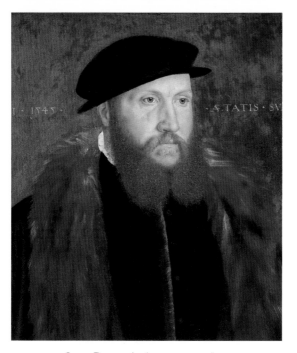

JOHN BETTES (active 1531–1570).
*A Man in a Black Cap,* 1545.
Oil on panel, 18½ x 16⅛ in. (47 x 41 cm).

17

of antiquity, as well as his less intellectual passion for hunting. Porter was a leading member of the court of Charles I, and at the time the portrait was painted he was fighting for the king in the war against Parliament, which eventually was to lead to the monarch's execution. Dobson successfully managed to convey Porter's character—and perhaps even the strain on him of the war—with great subtlety and sensitivity.

The seventeenth century also saw the beginning of two branches of painting that were to become ever more important to British art—landscapes and sporting pictures of animals and hunting scenes. One of the earliest and finest painters of landscape in Britain was again a foreigner. Jan Siberechts had come to England from Flanders for the first time in 1674 and stayed on for the rest of his life. *Landscape with Rainbow, Henley-on-Thames* (page 41), painted sometime around 1690, is one of his greatest masterpieces, and it is the most important early landscape in the Tate's collection. Siberechts captured all the subtle gradations and contrasts of light as it falls on the town and countryside in what is a conscious celebration of the English landscape, and perhaps even of its climate. This kind of poetic naturalism was to recur in British landscape painting through the years, eventually finding its fullest expression in the work of John Constable and Turner during the nineteenth century.

One of the earliest examples of a sporting subject in the collection is Francis Barlow's delightfully exuberant *Monkeys and Spaniels Playing* (page 40). Painted in 1661, it was probably made to hang over a door in a grand house. The British would develop an abiding passion for this genre of picture, culminating in the nineteenth century, although sporting pictures were frequently more savage than Barlow's.

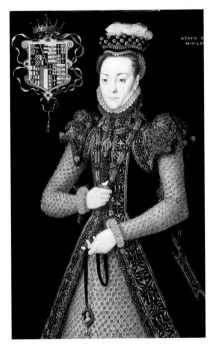

Hans Eworth (active 1540–1573).
*Portrait of a Lady, Probably of the Wentworth Family,* c. 1565–68.
Oil on panel, 23½ x 19 in. (99.8 x 61.9 cm).

20

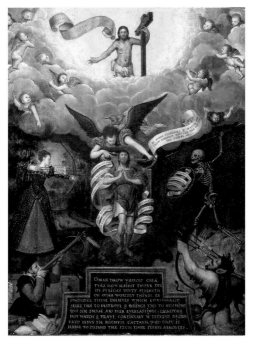

BRITISH SCHOOL (16th century).
*An Allegory of Man*, c. 1570.
Oil on panel, 22½ x 20¼ in. (57 x 51.4 cm).

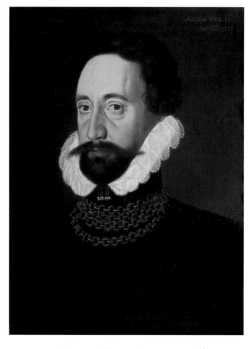

GEORGE GOWER (c. 1540–1596).
*Sir Thomas Kytson*, 1573.
Oil on panel, 20¾ x 15¾ in. (52.7 x 40 cm).

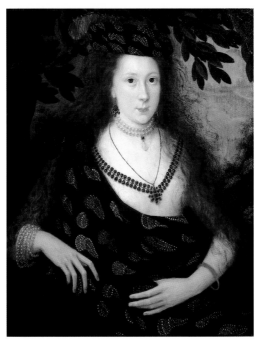

ATTRIBUTED TO ROBERT PEAKE (1551?–1619).
*Lady Elizabeth Pope,* c. 1615.
Oil on panel, 30½ x 24 in. (77.5 x 61 cm).

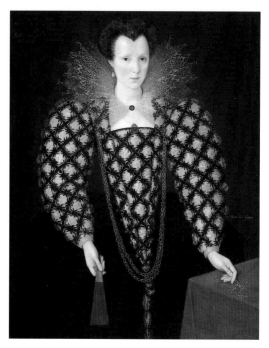

MARCUS GHEERAERTS THE YOUNGER (1561/62–1636).
*Portrait of Mary Rogers, Lady Harington,* 1592.
Oil on panel, 44½ x 33½ in. (113 x 85.1 cm).

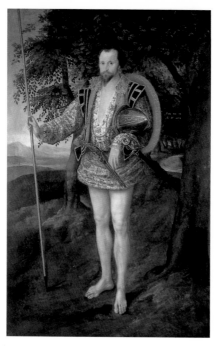

MARCUS GHEERAERTS THE YOUNGER (1561/62–1636).
*Portrait of Captain Thomas Lee,* 1594.
Oil on canvas, 90¾ x 59⅜ in. (230.5 x 150.8 cm).

BRITISH SCHOOL (17th century).
*The Cholmondeley Ladies,* c. 1600–1610.
Oil on panel, 35 x 68 in. (88.9 x 172.7 cm).

CORNELIUS JOHNSON (1593–1661).
*Portrait of Susanna Temple, Later Lady Lister,* 1620.
Oil on panel, 26¾ x 20⅜ in. (67.9 x 51.8 cm).

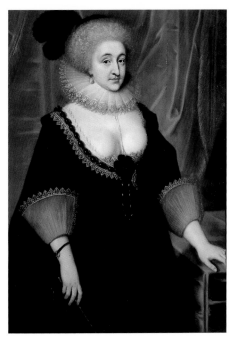

PAUL VAN SOMER (c. 1576–c. 1621/22).
*Lady Elizabeth Grey, Countess of Kent*, c. 1619.
Oil on panel, 81 x 50 in. (114.3 x 81.9 cm).

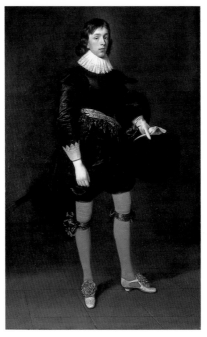

DANIEL MYTENS THE ELDER (c. 1590–c. 1647).
*Portrait of James Hamilton, Earl of Arran, Later 3rd Marquis
and 1st Duke of Hamilton, Aged 17, 1623.*
Oil on canvas, 79 x 49¼ in. (200.7 x 125.1 cm).

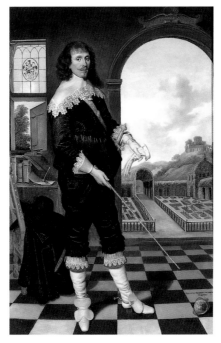

BRITISH SCHOOL (17th century).
*Portrait of William Style of Langley,* 1636.
Oil on canvas, 80¾ x 53½ in. (205.1 x 135.9 cm).

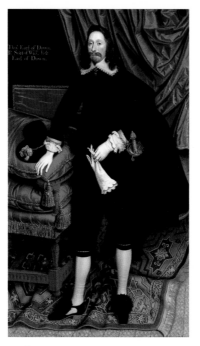

BRITISH SCHOOL (17th century).
*Portrait of Sir Thomas Pope, Later 3rd Earl of Downe*, c. 1635.
Oil on canvas, 79¾ x 47 in. (202.6 x 119.4 cm).

31

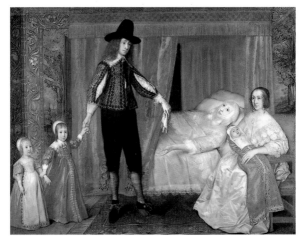

DAVID DES GRANGES (1611/13–1675?).
*The Saltonstall Family,* c. 1636–37.
Oil on canvas, 84¼ x 108¾ in. (214 x 276.2 cm).

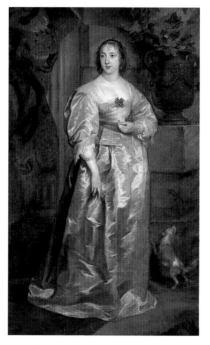

SIR ANTHONY VAN DYCK (1599–1641).
*A Lady of the Spencer Family*, c. 1633–38.
Oil on canvas, 81¾ x 50¼ in. (207.6 x 127.6 cm).

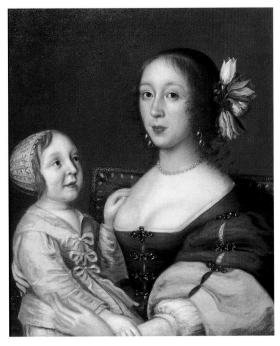

GILBERT JACKSON (active 1622–1640).
*A Lady of the Grenville Family and Her Son,* 1640.
Oil on canvas, 29½ x 23⅞ in. (74.2 x 60.8 cm).

34

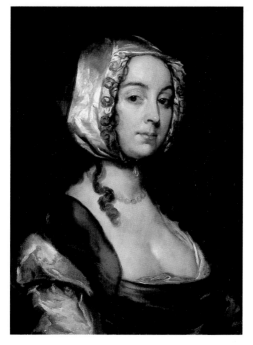

WILLIAM DOBSON (1611–1646).
*Portrait of the Artist's Wife,* c. 1635–40.
Oil on canvas, 24 x 18 in. (61 x 45.7 cm).

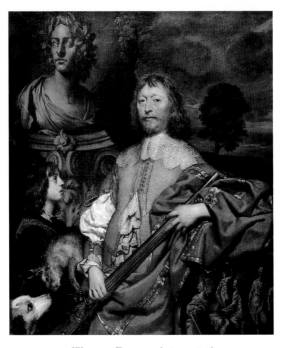

WILLIAM DOBSON (1611–1646).
*Endymion Porter,* c. 1642–45.
Oil on canvas, 59 x 50 in. (149.9 x 127 cm).

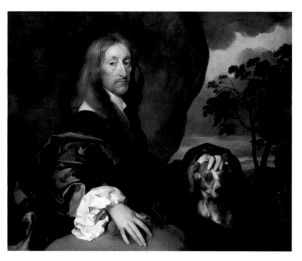

GERARD SOEST (c. 1600–1681).
*Portrait of a Gentleman with a Dog,*
*Probably Sir Thomas Tipping,* c. 1660.
Oil on canvas, 37 x 45¼ in. (93.9 x 114.9 cm). 37

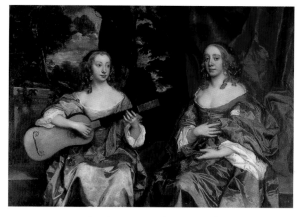

SIR PETER LELY (1618–1680).
*Two Ladies of the Lake Family,* c. 1660.
Oil on canvas, 50 x 71¼ in. (127 x 181 cm).

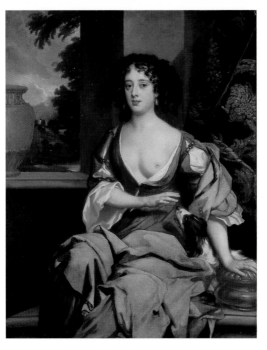

SIR PETER LELY (1618–1680).
*Margaret Hughes,* c. 1670–75.
Oil on canvas, 49¼ x 39½ in. (125.1 x 100.3 cm).

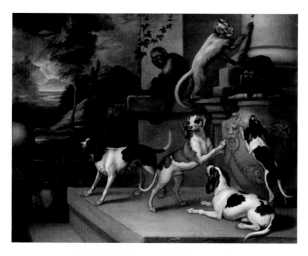

FRANCIS BARLOW (1626/27–1704).
*Monkeys and Spaniels Playing*, 1661.
Oil on canvas, 41½ x 52 in. (105.5 x 132 cm).

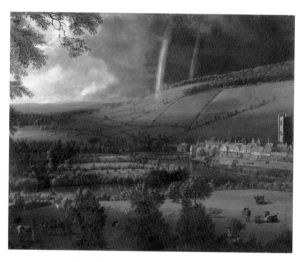

JAN SIBERECHTS (1627–c. 1700).
*Landscape with Rainbow, Henley-on-Thames,* c. 1690.
Oil on canvas, 32¼ x 40½ in. (81.9 x 102.9 cm).

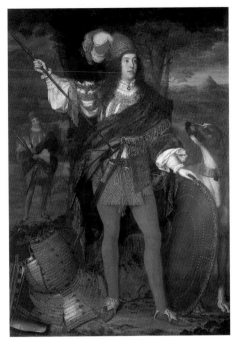

JOHN MICHAEL WRIGHT (1617–1694).
*Sir Neil O'Neill,* 1680.
Oil on canvas, 91⅝ x 64¼ in. (232.7 x 163.2 cm).

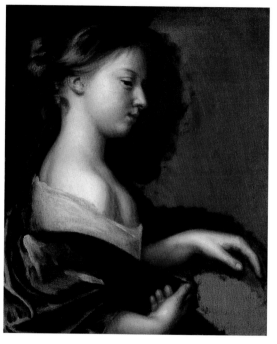

MARY BEALE (1633–1699).
*Portrait of a Young Girl*, c. 1681.
Oil on canvas, 21 x 18⅛ in. (53.5 x 46 cm).

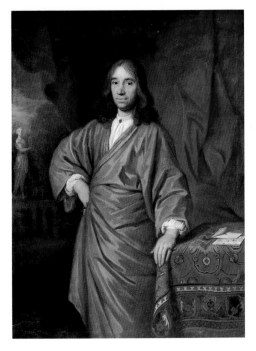

SIR GODFREY KNELLER (1646–1723).
*Portrait of John Banckes,* 1676.
Oil on canvas, 54 x 40 in. (137.2 x 101.6 cm).

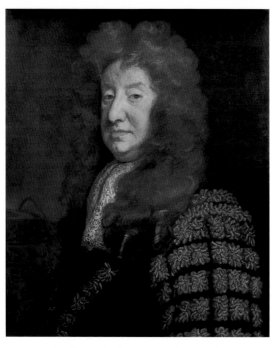

SIR GODFREY KNELLER (1646–1723).
*The First Marquess of Tweeddale*, 1695.
29½ x 25 in. (74.9 x 63.5 cm).

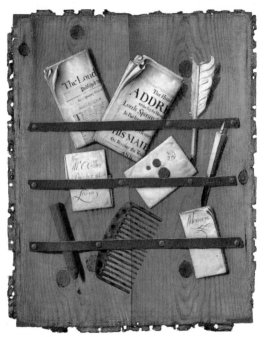

EDWARD COLLIER (active 1662–1707).
*A Trompe l'Oeil of Newspapers, Letters and
Writing Implements on a Wooden Board*, c. 1699.
Oil on canvas, 23¼ x 18¼ in. (58.8 x 46.2 cm).

46

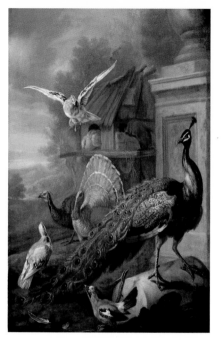

MARMADUKE CRADOCK (1660–1717).
*A Peacock and Other Birds in a Landscape,* c. 1700.
Oil on canvas, 30 x 24⅞ in. (76.1 x 63.2 cm).

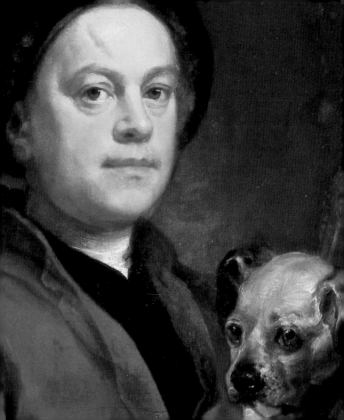

# WILLIAM HOGARTH AND HIS SUCCESSORS

The most important figure for British art in the first half of the eighteenth century was William Hogarth, who has justly been dubbed "The Father of British Painting." Hogarth evolved a style that was highly individual but also wholeheartedly and quintessentially British, and he was central to the formation, starting in the 1730s, of a generation of native-born British artists. Intensely patriotic, Hogarth was proud of the newfound identity and distinction of British art. The Tate collection has many of his pictures, including his deliberately self-confident portrait of himself with his pug dog (opposite and page 56) and the famous *O the Roast Beef of Old England* (page 57). Here Hogarth gave full vent to his anti-French feelings, in part caused by his arrest as a suspected spy in Calais in 1748. The large piece of beef in the picture symbolises the prosperity of England compared to that of France, whose ragged soldiers ogle the meat as it passes. So too does an obese monk, a personification by the Protestant Hogarth of his belief in the venality of the Roman Catholic Church of the day. On the extreme left of the picture Hogarth included himself, sketchbook in hand, just about to be seized by the French.

The second half of the eighteenth century saw the

continued growth in importance of elegant portraiture. Many portraits were painted in what was known as the "Grand Manner"—that is, adopting a confident, epic style taken from Michelangelo and Raphael. The natural subjects for such a style were the so-called history scenes from antiquity, the Bible, or Shakespeare, such as were painted by Benjamin West, James Barry, and John Hamilton Mortimer. The style's leading exponent was Sir Joshua Reynolds, the first president of the Royal Academy, who flatteringly depicted his sitters as characters from classical myth and history. His main rival as a portraitist was Thomas Gainsborough, who adopted some of the panache of the Grand Manner but also brought a delicacy and subtle naturalism to his subjects. The differences between the two rivals are easily seen in a comparison of the austere yet nevertheless bravura *Three Ladies Adorning a Term of Hymen* (page 70) by Reynolds and Gainsborough's much softer *Giovanna Baccelli* (page 77). Gainsborough's main interest, in fact, was in landscape, a genre at which he excelled, but he achieved greater financial success with portraiture.

Landscape was, nevertheless, an important element of British art by the second half of the eighteenth century. No country-house collection was complete without its landscape by the Welsh painter Richard Wilson, who took inspiration from the ideal classical scenes of

Claude Lorraine. The later part of the eighteenth century saw increased interest in "sublime" landscape, which expressed the awe inspired by nature's power, and this interest continued into the early decades of the following century. Eighteenth-century sublime landscape is typified by Joseph Wright's *Vesuvius in Eruption, with a View over the Islands in the Bay of Naples* (page 84), with its beautiful contrast of the destructive glow of molten lava with the cool calm of moonlight.

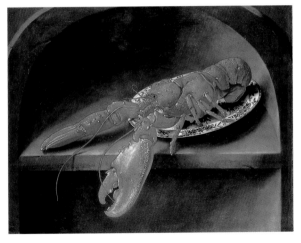

CHARLES COLLINS (c. 1680–1744).
*Lobster on a Delft Dish,* 1738.
Oil on canvas, 27¾ x 35¾ in. (70.5 x 91 cm).

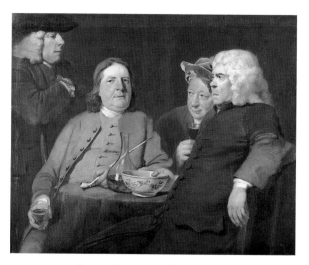

JOSEPH HIGHMORE (1692–1780).
*Mr. Oldham and His Guests*, c. 1735–45.
Oil on canvas, 41½ x 51 in. (105.5 x 129.5 cm).

53

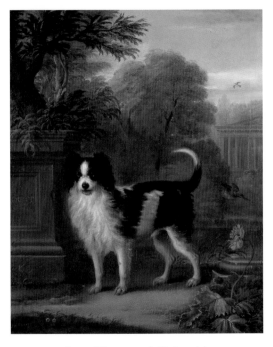

JOHN WOOTTON (1682?–1764).
*Muff, a Black and White Dog,* c. 1740–50.
Oil on canvas, 49¼ x 40 in. (125.1 x 101.6 cm).

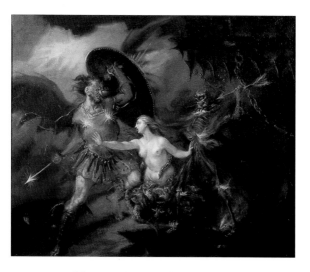

WILLIAM HOGARTH (1697–1764).
*Satan, Sin and Death*
*(A Scene from Milton's "Paradise Lost")*, c. 1735–40.
Oil on canvas, 24⅜ x 29⅜ in. (61.9 x 74.5 cm).

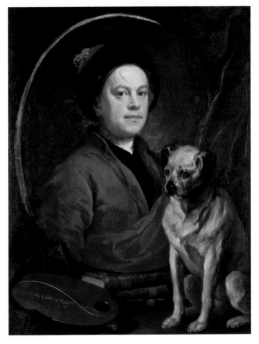

WILLIAM HOGARTH (1697–1764).
*The Painter and His Pug,* 1745.
Oil on canvas, 35½ x 27½ in. (90 x 69.9 cm).

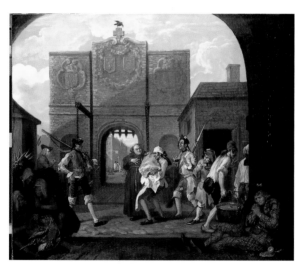

WILLIAM HOGARTH (1697–1764).
*O the Roast Beef of Old England ("The Gate of Calais")*, 1748.
Oil on canvas, 31 x 37¼ in. (78.8 x 94.5 cm).

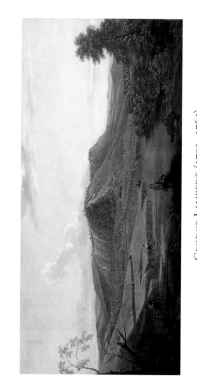

GEORGE LAMBERT (1700–1765).
*A View of Box Hill, Surrey*; 1733.
Oil on canvas, 35¾ x 72½ in. (90.8 x 180.4 cm).

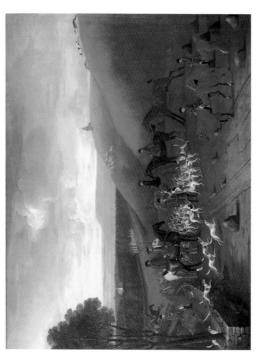

JAMES SEYMOUR (1702?–1752).
*A Kill at Ashdown Park*, 1743.
Oil on canvas, 71 x 94 in. (180.3 x 238.8 cm).

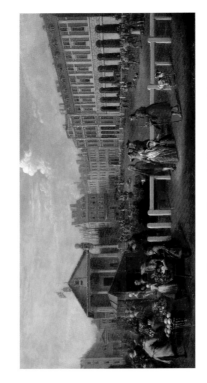

BALTHAZAR NEBOT (active 1730–1765).
*Covent Garden Market*, 1737.
Oil on canvas, 25 x 48½ in. (64.8 x 122.8 cm).

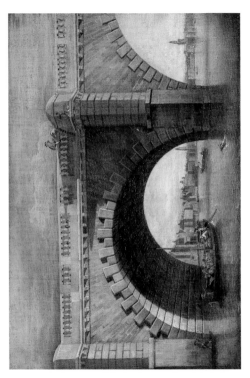

SAMUEL SCOTT (c. 1702–1772).
*An Arch of Westminster Bridge*, c. 1750.
Oil on canvas, 53¼ x 64½ in. (135.7 x 163.8 cm).

61

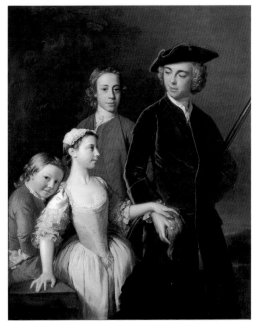

ALLAN RAMSAY (1713–1784).
*Thomas, 2nd Baron Mansel of Margam, with
His Blackwood Half-Brothers and Sister*, 1742.
Oil on canvas, 49½ x 39½ in. (124.5 x 100.3 cm).

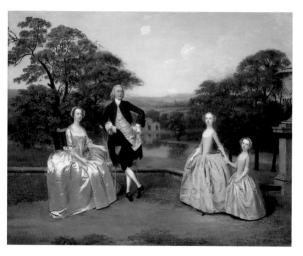

ARTHUR DEVIS (1711–1787).
*The James Family*, 1751.
Oil on canvas, 38¾ x 49 in. (98.4 x 124.5 cm).

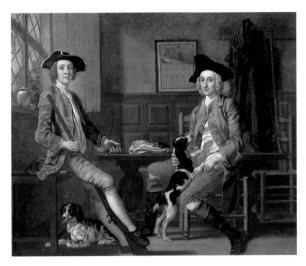

FRANCIS HAYMAN (1708–1776).
*Thomas Nuthall and His Friend Hambleton Custance*, c. 1748.
Oil on canvas, 28 x 36 in. (71 x 91.5 cm).

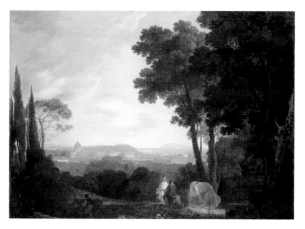

RICHARD WILSON (1713–1782).
*Rome: St. Peter's and the Vatican from the Janiculum,* c. 1753.
Oil on canvas, 39½ x 54¾ in. (100.3 x 139.1 cm).

65

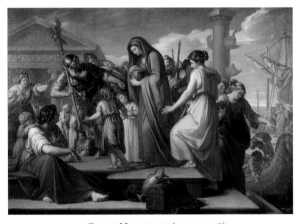

GAVIN HAMILTON (1723–1798).
*Agrippina Landing at Brindisium with
the Ashes of Germanicus*, 1765–72.
Oil on canvas, 71¾ x 101¼ in. (182.5 x 256 cm).

66

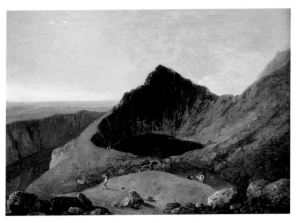

RICHARD WILSON (1713–1782).
*Llyn-y-Cau, Cader Idris*, exhibited 1774(?).
Oil on canvas, 20⅛ x 28¾ in. (51.1 x 73 cm).

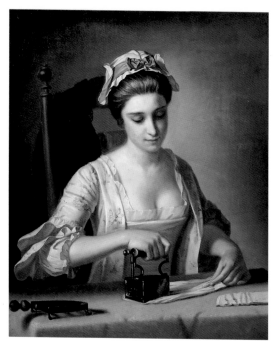

HENRY ROBERT MORLAND (1716–1797).
*A Laundry Maid Ironing,* c. 1765–82.
Oil on canvas, 29¼ x 24¼ in. (74.3 x 61.6 cm).

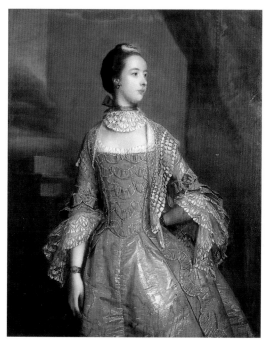

SIR JOSHUA REYNOLDS (1723–1792).
*Suzanna Beckford,* 1756.
Oil on canvas, 50 x 40¼ in. (127 x 102.2 cm).

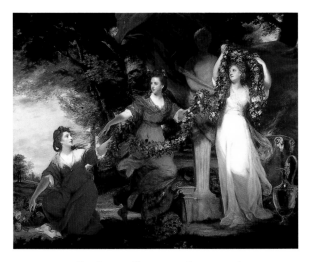

SIR JOSHUA REYNOLDS (1723–1792).
*Three Ladies Adorning a Term of Hymen*, 1773.
Oil on canvas, 92 x 114½ in. (233.7 x 290.8 cm).

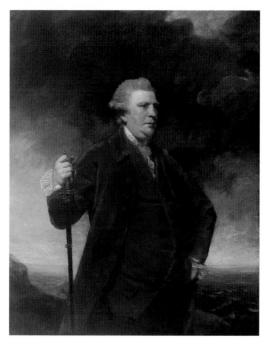

SIR JOSHUA REYNOLDS (1723–1792).
*Admiral Viscount Keppel*, 1780.
Oil on canvas, 49 x 39 in. (124.5 x 99.1 cm).

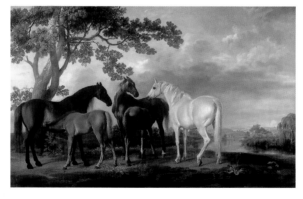

GEORGE STUBBS (1724–1806).
*Mares and Foals in a River Landscape,* c. 1763–68.
Oil on canvas, 40 x 63¼ in. (101.6 x 161.9 cm).

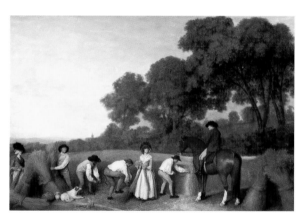

GEORGE STUBBS (1724–1806).
*Reapers,* 1785.
Oil on panel, 35⅜ x 53⅞ in. (89.9 x 136.8 cm).

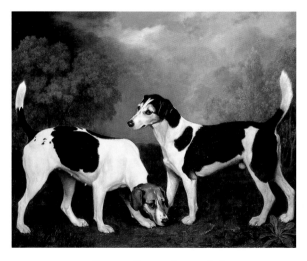

GEORGE STUBBS (1724–1806).
*A Couple of Foxhounds,* 1792.
Oil on canvas, 40 x 50 in. (101.6 x 127 cm).

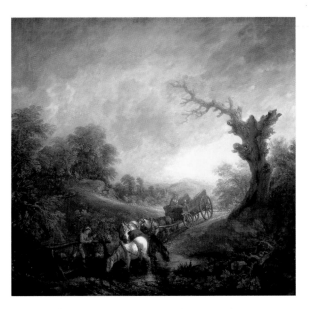

THOMAS GAINSBOROUGH (1727–1788).
*Sunset: Carthorses Drinking at a Stream,* c. 1760.
Oil on canvas, 56½ x 60½ in. (143.5 x 153.7 cm).

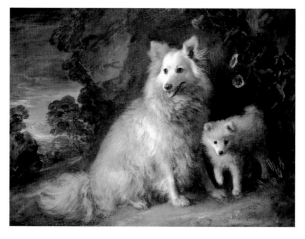

THOMAS GAINSBOROUGH (1727–1788).
*Pomeranian Bitch and Puppy*, c. 1777.
Oil on canvas, 32¾ x 44 in. (83.2 x 111.8 cm).

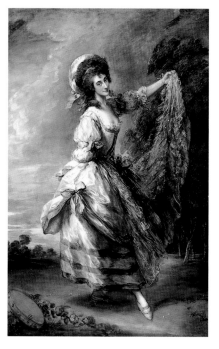

THOMAS GAINSBOROUGH (1727–1788).
*Giovanna Baccelli*, exhibited 1782.
Oil on canvas, 89¼ x 58½ in. (226.7 x 148.6 cm).

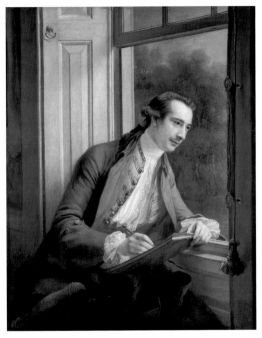

FRANCIS COTES (1726–1770).
*Paul Sandby*, 1761.
Oil on canvas, 49¼ x 39½ in. (125.1 x 100.3 cm).

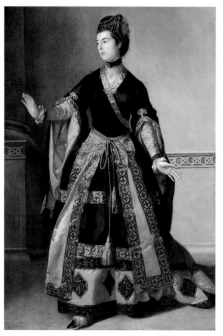

TILLY KETTLE (1734/35–1786).
*Mrs. Yates as Mandane in
"The Orphan of China,"* exhibited 1765.
Oil on canvas, 75⅞ x 51⅛ in. (192.4 x 129.5 cm).

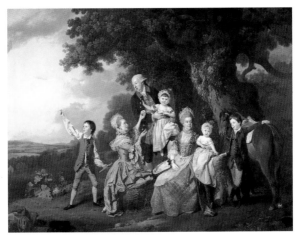

JOHANN ZOFFANY (1733–1810).
*The Bradshaw Family,* exhibited 1769.
Oil on canvas, 52 x 69 in. (162.1 x 175.3 cm).

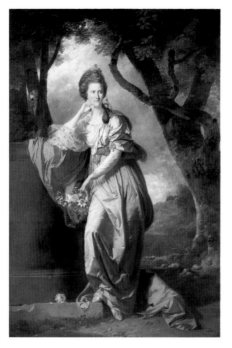

JOHANN ZOFFANY (1733–1810).
*Mrs. Woodhull,* c. 1770.
Oil on canvas, 96 x 65 in. (243.8 x 165.1 cm).

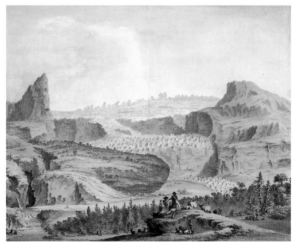

SAMUEL HIERONYMOUS GRIMM (1733–1794).
*The Glacier of Simmenthal,* 1774. Pen and ink and watercolour
on paper, 11⅝ x 14⅝ in. (29.5 x 37.1 cm).

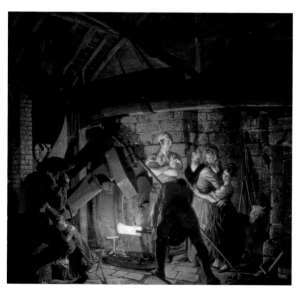

JOSEPH WRIGHT OF DERBY (1734–1797).
*An Iron Forge,* 1772.
Oil on canvas, 47¾ x 52 in. (121.3 x 132 cm).

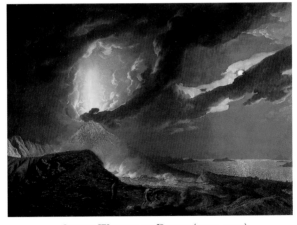

JOSEPH WRIGHT OF DERBY (1734–1797).
*Vesuvius in Eruption, with a View over the Islands
in the Bay of Naples,* c. 1776–80.
Oil on canvas, 48⅛ x 69½ in. (122 x 176.4 cm).

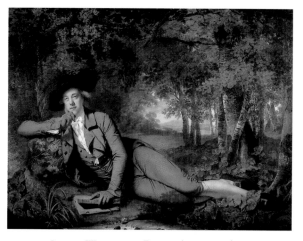

JOSEPH WRIGHT OF DERBY (1734–1797).
*Sir Brooke Boothby*, 1781.
Oil on canvas, 58½ x 81¾ in. (148.6 x 207.6 cm).

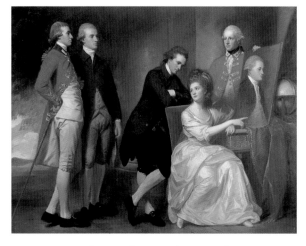

GEORGE ROMNEY (1734–1802).
*The Beaumont Family,* 1777–79.
Oil on canvas, 80½ x 107 in. (204.5 x 271.8 cm).

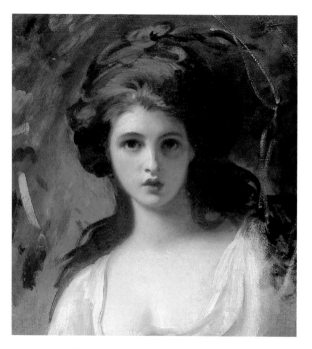

GEORGE ROMNEY (1734–1802).
*Lady Hamilton as Circe,* c. 1782.
Oil on canvas, 21 x 19½ in. (53.3 x 49.5 cm).

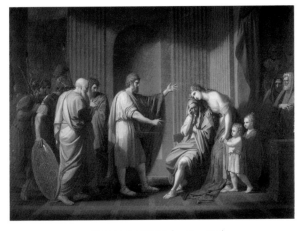

Benjamin West (1738–1820).
*Cleombrotus Ordered into Banishment by Leonidas II,*
*King of Sparta, 1768.*
Oil on canvas, 54½ x 73 in. (138.4 x 185.4 cm).

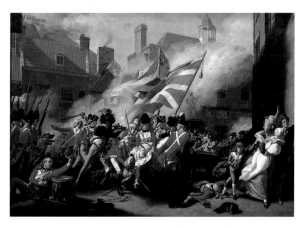

JOHN SINGLETON COPLEY (1738–1815).
*The Death of Major Peirson, 6 January 1781*, 1783.
Oil on canvas, 8 ft. 9 in. x 12 ft. (2.515 x 3.658 m).

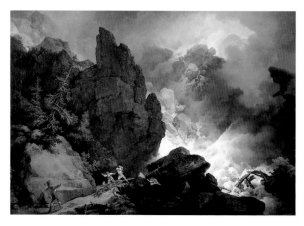

PHILIP JAMES DE LOUTHERBOURG (1740–1812).
*An Avalanche in the Alps,* 1803.
Oil on canvas, 43¼ x 63 in. (109.9 x 160 cm).

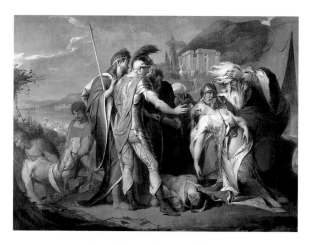

James Barry (1741–1806).
*King Lear Weeping over the Dead Body of Cordelia*, 1786–88.
Oil on canvas, 8 ft. 10 in. x 12 ft. ½ in. (2.692 x 3.67 m).

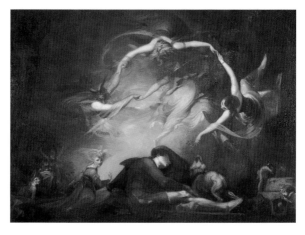

HENRY FUSELI (1741–1825).
*The Shepherd's Dream, from "Paradise Lost,"* 1793.
Oil on canvas, 60¾ x 84¾ in. (154.3 x 215.3 cm).

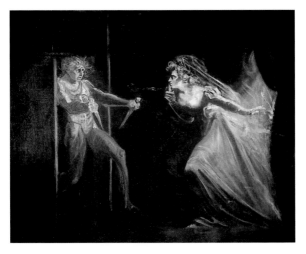

HENRY FUSELI (1741–1825).
*Lady Macbeth Seizing the Daggers,* exhibited 1812(?).
Oil on canvas, 40 x 50 in. (101.6 x 127 cm).

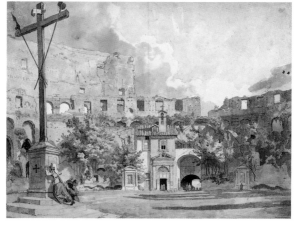

WILLIAM PARS (1742–1782).
*The Interior of the Colosseum,* c. 1775. Pencil, watercolour, and
pen and ink on paper, 17⅛ x 23¼ in. (43.5 x 59.1 cm).

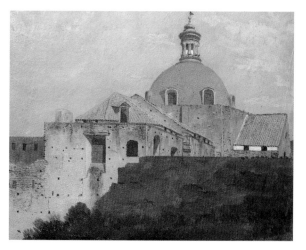

THOMAS JONES (1742–1803).
*Naples: The Capella Nuova Outside the Porta di Chiaja,* 1782.
Oil on paper, 7⅜ x 9⅛ in. (20 x 23.2 cm).

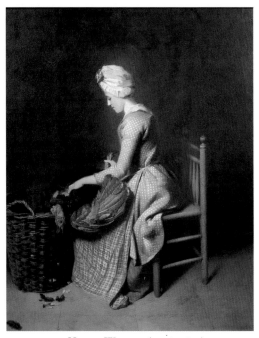

HENRY WALTON (1746–1813).
*Plucking the Turkey,* exhibited 1776.
Oil on canvas, 30 x 25 in. (76.2 x 63.5 cm).

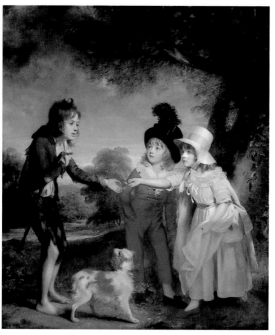

SIR WILLIAM BEECHEY (1753–1839).
*Portrait of Sir Francis Ford's Children*
*Giving a Coin to a Beggar Boy*, exhibited 1793.
Oil on canvas, 71⅛ x 59⅛ in. (180.5 x 150 cm).

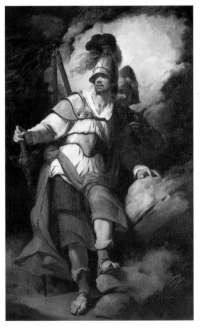

JOHN HAMILTON MORTIMER (1740–1779).
*Sir Arthegal, the Knight of Justice, with Talus, the Iron Man
(from Spenser's "Faerie Queene")*, exhibited 1778.
Oil on canvas, 95½ x 57½ in. (242.6 x 146 cm).

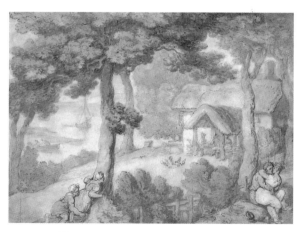

THOMAS ROWLANDSON (1756–1827).
*Landscape, Isle of Wight*, c. 1782(?). Pen and ink and
watercolour on paper, 7⅞ x 10⅞ in. (20 x 27.6 cm).

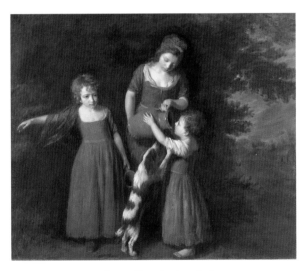

JOHN OPIE (1761–1807).
*The Peasant's Family,* c. 1783–85.
Oil on canvas, 60½ x 72¼ in. (153.7 x 183.5 cm).

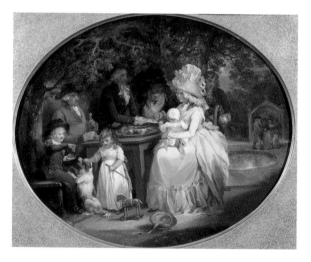

GEORGE MORLAND (1763–1804).
*The Tea Garden*, c. 1790.
Oil on canvas, 16 x 19⅞ in. (40.6 x 50.5 cm).

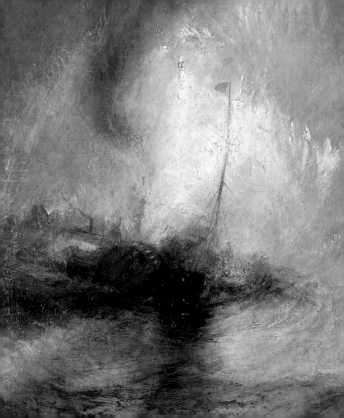

# ROMANTICISM AND THE EARLY NINETEENTH CENTURY

The first half of the nineteenth century saw great developments in landscape painting and the attempt by some artists to raise its status within the hierarchy of painting subjects. One of the most important landscape painters of the first decades of the nineteenth century was John Constable, whose "six footer" canvases controversially tried to raise the scale and therefore the status of landscapes to that associated with history painting. His pictures were based upon careful observation of nature, in which the artist perceived the reflection of God's creation. His landscapes exude tranquillity and calm, but they were considered too advanced when first exhibited early in the nineteenth century. Although Constable achieved only limited success in his lifetime, his pictures are now considered among the highlights of the Tate collection.

Joseph Mallord William Turner was the outstanding innovator of his day and probably of his century. Constable commented of him that he painted "with tinted steam," and it is exactly the changing, transient effects of light and atmosphere that often make his pictures so distinctive. Turner achieved great success at the Royal Academy in his early career, but by the 1840s his mature

style was criticised for "indistinctness," and his perception of landscape was thought eccentric if not insane. He was fascinated throughout his long career by the threat of natural disaster, as demonstrated by *Snow Storm: Hannibal and His Army Crossing the Alps* (page 120) and *Snow Storm: Steam-Boat off a Harbour's Mouth* (pages 102 and 124). The latter, now one of Turner's most famous pictures, was derided by the critics of the day as "so much soapsuds and whitewash." Turner had sought to give a sense of the feeling of being in the grip of a violent storm at sea, rather than to depict it in minute detail, and in doing so he managed to achieve a greater degree of realism.

The other genius of the late eighteenth and early nineteenth centuries was William Blake, an artist and visionary who, unlike Constable and Turner, looked inwards to find a greater truth. Having achieved little recognition in his own lifetime, Blake is now recognised as one of the most original minds of his age. He was passionately antimaterialist and believed in the profound spirituality of the inner life. Through his art and writings he evolved an intensely personal iconography to communicate his vision, which apart from a small band of admirers including the artists John Linnell, John Varley, and Samuel Palmer, was steadfastly ignored. Blake's work is richly represented at the Tate, including his famous *Ghost of a Flea* (page 108). This records a curious vision

that appeared to Blake during a seance at John Varley's house. While Blake sketched it, Varley reported, "the Flea told him that all fleas were inhabited by the souls of such men as were by nature blood thirsty to excess." The Tate also owns twenty of the illustrations to Dante that Blake made late in his career, commissioned by John Linnell. Blake stands slightly outside the main developments of art in late-eighteenth- and early-nineteenth-century Britain, although the products of the imagination were a recurrent strand, from Henry Fuseli's nightmarish fantasies (pages 92–93) through to the fairy pictures of Richard Dadd (page 150) and the apocalyptic drama of John Martin's Judgement Day triptych (page 140) in the mid-nineteenth century.

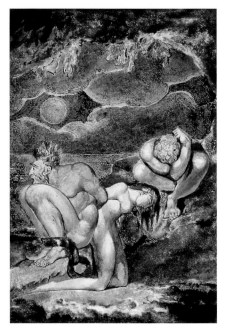

WILLIAM BLAKE (1757–1827).
*Frontispiece to "Visions of the Daughters of Albion,"* c. 1795.
Colour-printed relief etching finished in ink and
watercolour on paper, 6¾ x 4¾ in. (17 x 12 cm).

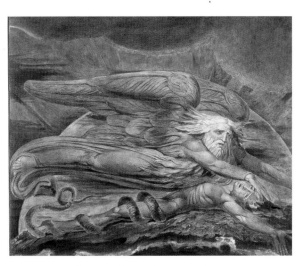

WILLIAM BLAKE (1757–1827).
*Elohim Creating Adam*, 1795/c. 1805.
Colour print finished in ink and watercolour on paper,
17 x 21⅛ in. (43.1 x 53.6 cm).

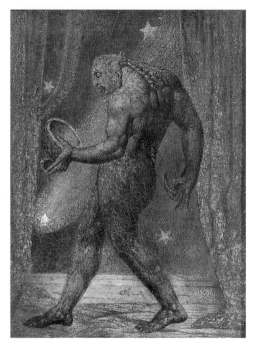

WILLIAM BLAKE (1757–1827).
*The Ghost of a Flea,* c. 1819–20. Tempera heightened
with gold on panel, 8½ x 6⅜ in. (21.4 x 16.2 cm).

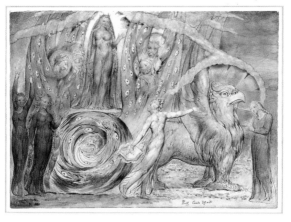

WILLIAM BLAKE (1757–1827).
*Beatrice Addressing Dante from the Car,* 1824–27. Pen and
watercolour on paper, 14⅝ x 20¾ in. (37.2 x 52.7 cm).

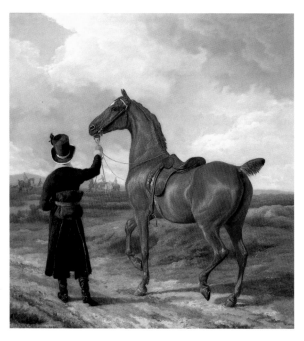

JACQUES-LAURENT AGASSE (1767–1849).
*Lord Rivers's Groom Leading a Chestnut Hunter Towards a
Coursing Party in Hampshire,* 1807.
Oil on canvas, 26 x 24⅝ in. (66 x 62.5 cm).

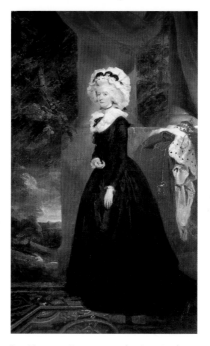

SIR THOMAS LAWRENCE (1769–1830).
*Philadelphia Hannah, 1st Viscountess Cremorne,* exhibited 1789.
94½ x 58¼ in. (240.3 x 148 cm).

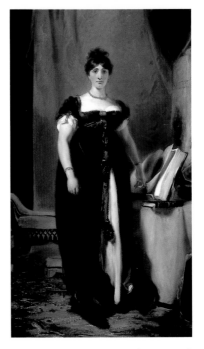

SIR THOMAS LAWRENCE (1769–1830).
*Mrs. Siddons,* 1804.
Oil on canvas, 100 x 58¼ in. (254 x 148 cm).

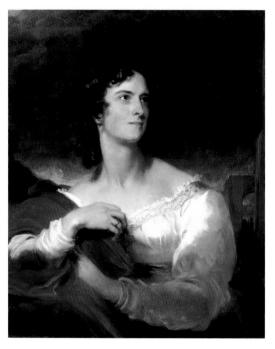

SIR THOMAS LAWRENCE (1769–1830).
*Miss Caroline Fry*, 1827.
Oil on canvas, 29¾ x 24¾ in. (75.6 x 62.9 cm).

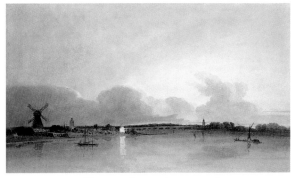

THOMAS GIRTIN (1775–1802).
*The White House at Chelsea,* 1800.
Watercolour on paper, 11¾ x 20¼ in. (29.8 x 51.4 cm).

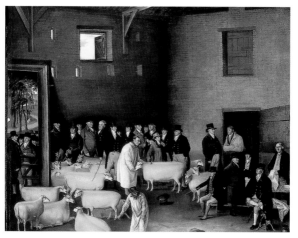

THOMAS WEAVER (1774/75–1843).
*Ram-Letting from Robert Bakewell's Breed at Dishley,*
*near Loughborough, Leicestershire,* 1810.
Oil on canvas, 40½ x 50⅝ in. (102.8 x 128.6 cm).

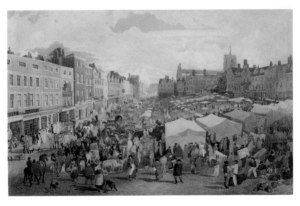

JOHN SELL COTMAN (1782–1842).
*Norwich Market-Place*, c. 1806.
Watercolour on paper, 16 x 25½ in. (40.6 x 64.8 cm).

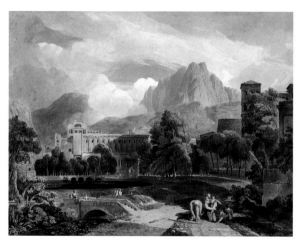

JOHN VARLEY (1778–1842).
*Suburbs of an Ancient City,* 1808.
Watercolour on paper, 28½ x 38 in. (72.2 x 96.5 cm).

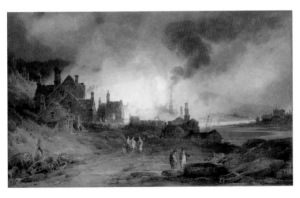

PAUL SANDBY MUNN (1773–1845).
*Bedlam Furnace, Madeley Dale, Shropshire*, 1803.
Pencil and watercolour on paper,
12¾ x 21⅝ in. (32.5 x 54.8 cm).

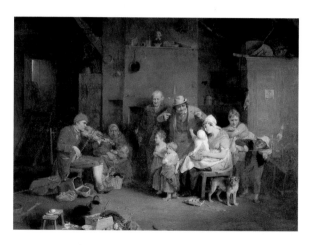

SIR DAVID WILKIE (1785–1841).
*The Blind Fiddler*, 1806.
Oil on panel, 22¾ x 31¼ in. (57.8 x 79.4 cm).

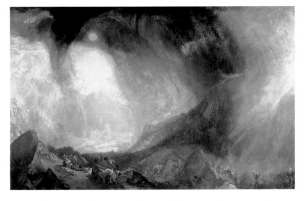

JOSEPH MALLORD WILLIAM TURNER (1775–1851).
*Snow Storm: Hannibal and His Army Crossing the Alps,*
exhibited 1812. Oil on canvas, 57 x 93 in. (146 x 237.5 cm).

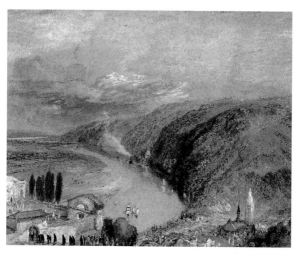

JOSEPH MALLORD WILLIAM TURNER (1775–1851).
*Caudebec*, c. 1832.
Gouache on paper, 5½ x 7½ in. (13.9 x 19.2 cm).

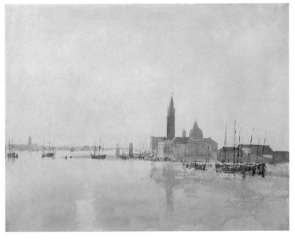

JOSEPH MALLORD WILLIAM TURNER (1775–1851).
*Venice: San Giorgio Maggiore from the Dogana,* c. 1840.
Pencil, watercolour, and gouache on paper,
7½ x 11 in. (19.3 x 28.1 cm).

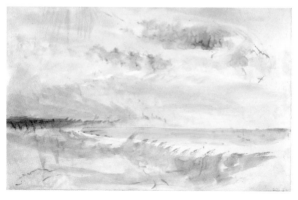

Joseph Mallord William Turner (1775–1851).
*Beach Scene*, c. 1845.
Watercolour on paper, 11 x 17⅜ in. (28 x 44 cm).

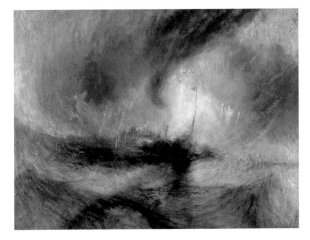

JOSEPH MALLORD WILLIAM TURNER (1775–1851).
*Snow Storm: Steam-Boat off a Harbour's Mouth*, exhibited 1842.
Oil on canvas, 36 x 48 in. (91.4 x 121.9 cm).

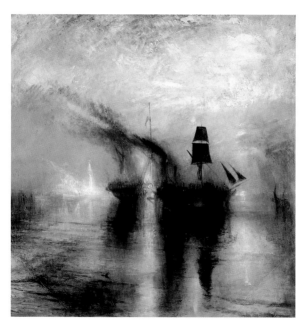

JOSEPH MALLORD WILLIAM TURNER (1775–1851).
*Peace—Burial at Sea*, exhibited 1842.
Oil on canvas, 34¼ x 34⅛ in. (87 x 86.7 cm).

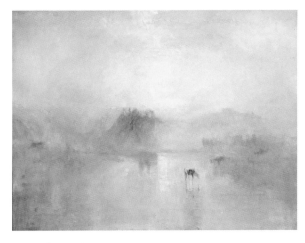

JOSEPH MALLORD WILLIAM TURNER (1775–1851).
*Norham Castle, Sunrise,* c. 1845.
Oil on canvas, 35¾ x 48 in. (90.8 x 121.9 cm).

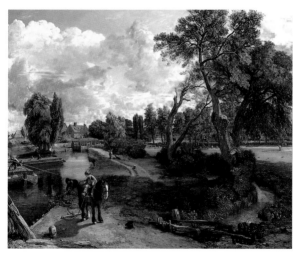

JOHN CONSTABLE (1776–1837).
*Flatford Mill ("Scene on a Navigable River"),* 1816–17.
Oil on canvas, 40 x 50 in. (101.6 x 127 cm).

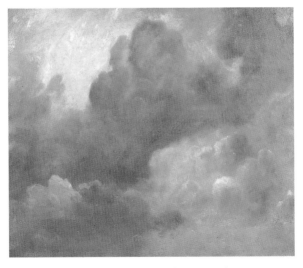

JOHN CONSTABLE (1776–1837).
*Cloud Study,* 1822.
Oil on paper, 18¾ x 22⅝ in. (47.6 x 57.5 cm).

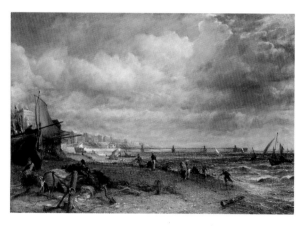

JOHN CONSTABLE (1776–1837).
*Chain Pier, Brighton*, 1826–27.
Oil on canvas, 50 x 72 in. (127 x 182.9 cm).

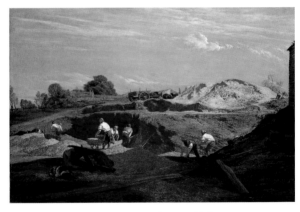

JOHN LINNELL (1792–1882).
*Kensington Gravel Pits,* 1811–12.
Oil on canvas, 28 x 42 in. (71.1 x 106.7 cm).

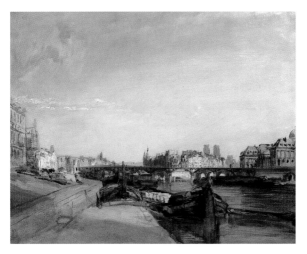

RICHARD PARKES BONINGTON (1802–1828).
*The Pont des Arts, Paris,* c. 1826.
Oil on board, 14 x 17¾ in. (35.6 x 45.1 cm).

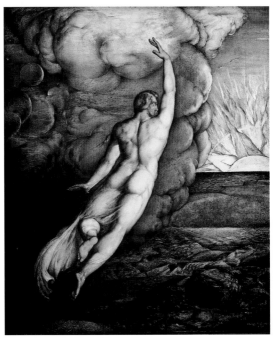

GEORGE RICHMOND (1809–1896).
*The Creation of Light*, 1826. Tempera, gold, and silver
on panel, 18⅞ x 16⅜ in. (48 x 41.7 cm).

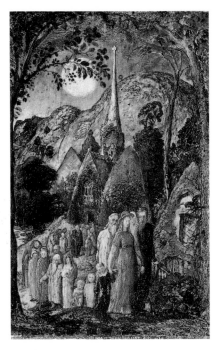

SAMUEL PALMER (1805–1881).
*Coming from Evening Church,* 1830.
Tempera on paper, 11⅞ x 7⅞ in. (30.2 x 20 cm).

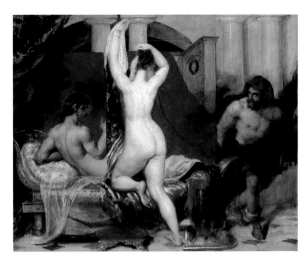

WILLIAM ETTY (1787–1849).
*Candaules, King of Lydia, Shews His Wife by Stealth to Gyges,*
*One of His Ministers, as She Goes to Bed,* exhibited 1830.
134        Oil on canvas, 17¾ x 22 in. (45.1 x 55.9 cm).

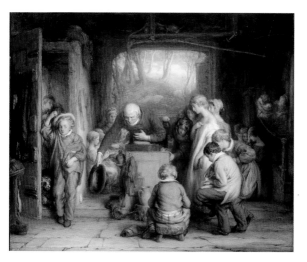

WILLIAM MULREADY (1786–1863).
*The Last In,* 1834–35.
Oil on panel, 24½ x 30 in. (62.2 x 76.2 cm).

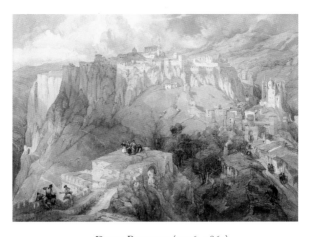

DAVID ROBERTS (1796–1864).
*Ronda,* 1834.
Pencil and watercolour on paper, 9¼ x 13 in. (23.5 x 33 cm).

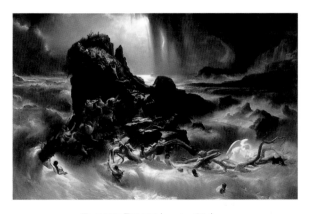

FRANCIS DANBY (1793–1861).
*The Deluge,* exhibited 1840.
Oil on canvas, 9 ft. 4 in. x 14 ft. 10 in. (2.845 x 4.521 m).

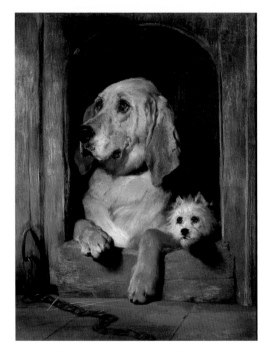

SIR EDWIN HENRY LANDSEER (1803–1874).
*Dignity and Impudence,* 1839.
Oil on canvas, 35 x 27¼ in. (88.9 x 69.2 cm).

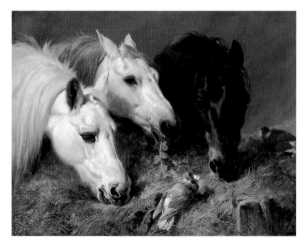

JOHN FREDERICK HERRING (1795–1865).
*The Frugal Meal,* exhibited 1847.
Oil on canvas, 21½ x 29½ in. (54.6 x 74.9 cm).

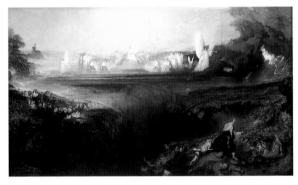

JOHN MARTIN (1789–1854).
*The Last Judgement,* 1853.
Oil on canvas, 77½ x 119⅜ in. (196.8 x 325.8 cm).

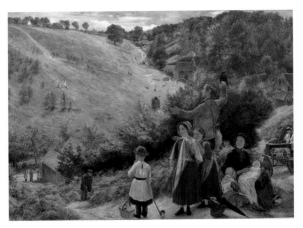

RICHARD REDGRAVE (1804–1888).
*The Emigrant's Last Sight of Home*, 1858.
Oil on canvas, 26¾ x 38¾ in. (67.9 x 98.4 cm).

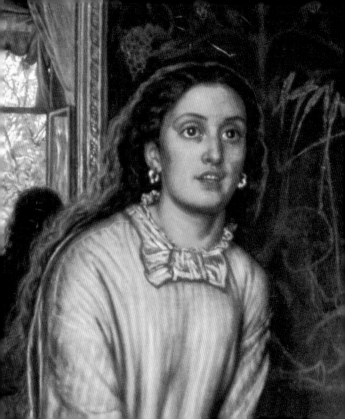

# THE LATE NINETEENTH CENTURY

The second half of the nineteenth century saw rapid changes of style, content, and technique in British art. One of the most significant early events of the era was the foundation of the Pre-Raphaelite Brotherhood in 1848 by John Everett Millais, William Holman Hunt, and Dante Gabriel Rossetti. They rejected the style derived from late Raphael, the freely handled paint, and the trivial subject matter that they felt then prevailed. Using a highly detailed technique, they painted serious subjects, often drawn from myth or poetry and containing a wealth of symbolism and allusion. Initially much criticised, they were championed by John Ruskin and became highly influential. They established an appetite for Symbolism in British art, most clearly evident in the work of Edward Burne-Jones, George Frederic Watts, Frederic, Lord Leighton, and late Rossetti, all of whom looked at the spiritual dimensions of human life.

Genre scenes from everyday life, often with a strong moral message or humorous content, were popular for most of the nineteenth century. The innocence of the rustic tableaux from the earlier part of the century, such as those by David Wilkie and William Mulready reproduced here (pages 119 and 135), contrast markedly with

some of those painted later, such as Augustus Leopold Egg's *Past and Present, No. 1* (page 147), which warns of the grim consequences of infidelity in marriage. The husband has intercepted a note from his wife's lover, and the falling house of cards symbolises the collapse of their life. The first part of a triptych, it is followed by pictures that trace the woman's descent into homelessness, poverty, and early death.

In the 1870s some artists began to paint "social realist" pictures based on the everyday hardship that faced ordinary people who toiled in the factory or on the land. They combined many of the elements of genre with an often grim realism. Luke Fildes's *The Doctor* (page 195) is an outstanding example, showing the devotion of a country physician to his young patient. Fildes went to great lengths to ensure the accuracy of what he fully intended to be his most powerful work; he constructed a careful replica of a cottage interior in his London studio and rose early each morning to accurately capture the dawn.

One of the most significant figures of the 1860s and '70s was the American James McNeill Whistler, who challenged all the assumptions of British art of the day. He had settled in London in 1859 and championed the aesthetic of art for art's sake in the 1870s, suppressing narrative in his pictures in favour of mood and emotion. This approach found little favour with those who believed in

the primacy of subject or meticulous technique, and the clash between the two viewpoints was made formal when Whistler sued Ruskin for libel after the critic had attacked his pictures for their lack of intellectual content. Whistler laid the way for the admiration of Impressionist painting by many British artists in the 1880s, who finally abandoned the supremacy of subject for a more sensuous delight in colour, texture, and the effects of light.

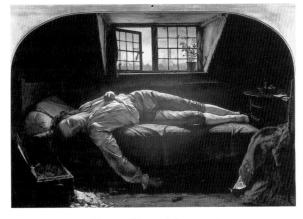

HENRY WALLIS (1830–1916).
*Chatterton,* 1856.
Oil on canvas, 24½ x 36¾ in. (62.2 x 93.3 cm).

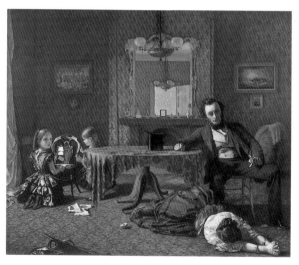

Augustus Leopold Egg (1816–1863).
*Past and Present, No. 1,* 1858.
Oil on canvas, 25 x 30 in. (63.5 x 76.2 cm).

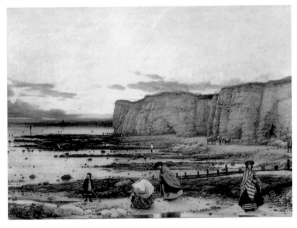

WILLIAM DYCE (1806–1864).
*Pegwell Bay, Kent—a Recollection of October 5th 1858,*
1858(?)–60. Oil on canvas, 25 x 35 in. (63.5 x 88.9 cm).

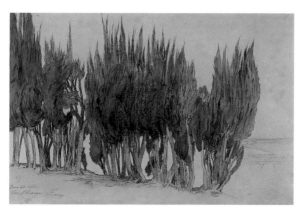

EDWARD LEAR (1812–1888).
*Villa S. Firenze,* 1861. Pen and ink and watercolour
on paper, 9 x 13⅞ in. (22.9 x 35.2 cm).

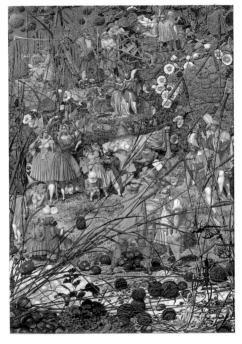

RICHARD DADD (1817–1886).
*The Fairy Feller's Master-Stroke,* 1855–64.
Oil on canvas, 21¼ x 15½ in. (54 x 39.4 cm).

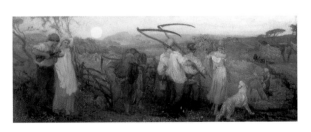

GEORGE MASON (1818–1872).
*The Harvest Moon,* exhibited 1872.
Oil on canvas, 34 x 91 in. (86.4 x 231.1 cm).

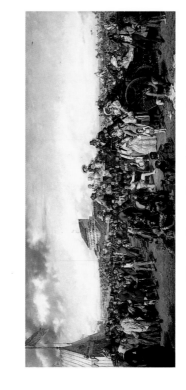

WILLIAM POWELL FRITH (1819–1909).
*The Derby Day*, 1856–58.
Oil on canvas, 40 x 88 in. (101.6 x 223.5 cm).

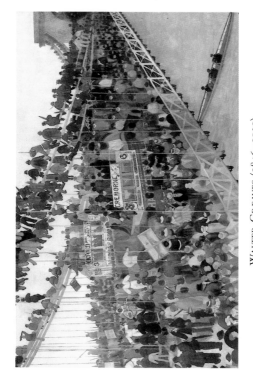

WALTER GREAVES (1846–1930).
*Hammersmith Bridge on Boat-Race Day*, c. 1862.
Oil on canvas, 36 x 55 in. (91.4 x 139.7 cm).

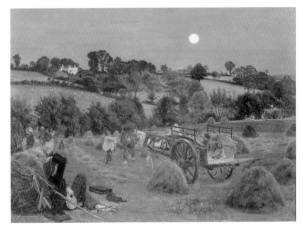

FORD MADOX BROWN (1821–1893).
*The Hayfield,* 1855–56.
Oil on panel, 9½ x 13⅛ in. (24.1 x 33.3 cm).

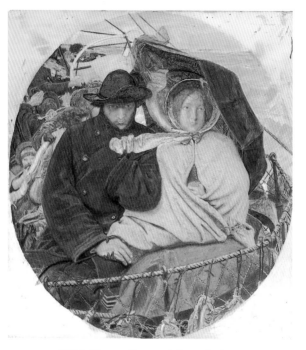

FORD MADOX BROWN (1821–1893).
*The Last of England,* 1864–66.
Watercolour on paper, 14 x 13 in. (35.6 x 33 cm).

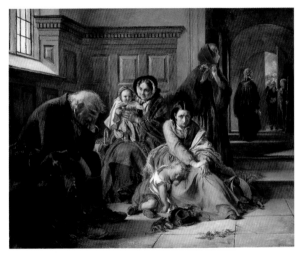

ABRAHAM SOLOMON (1824–1862).
*Waiting for the Verdict*, 1857.
Oil on canvas, 40⅛ x 50⅛ in. (101.9 x 127.3 cm).

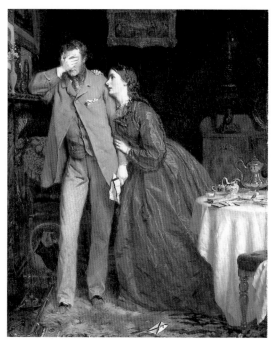

GEORGE ELGAR HICKS (1824–1914).
*Woman's Mission: Companion of Manhood,* 1863.
Oil on canvas, 30 x 25¼ in. (76.2 x 64.1 cm).

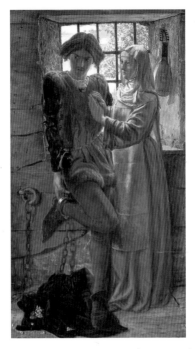

WILLIAM HOLMAN HUNT (1827–1910).
*Claudio and Isabella,* 1850.
Oil on panel, 30½ x 18 in. (77.5 x 45.7 cm).

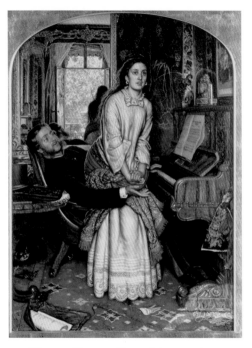

WILLIAM HOLMAN HUNT (1827–1910).
*The Awakening Conscience*, 1853.
Oil on canvas, 30 x 20 in. (76.2 x 55.9 cm).

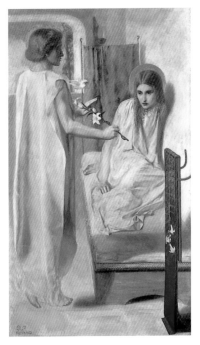

DANTE GABRIEL ROSSETTI (1828–1882).
*Ecce Ancilla Domini! (The Annunciation),* 1849–50.
Oil on canvas, 28½ x 16½ in. (72.4 x 41.9 cm).

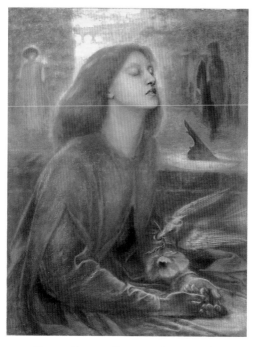

DANTE GABRIEL ROSSETTI (1828–1882).
*Beata Beatrix*, c. 1864–70.
Oil on canvas, 34 x 26 in. (86.4 x 66 cm).

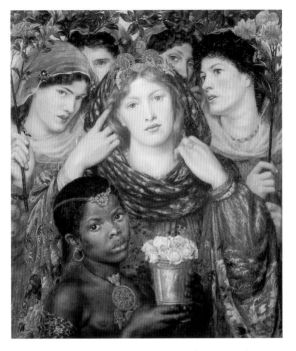

DANTE GABRIEL ROSSETTI (1828–1882).
*The Beloved ("The Bride"), 1865–66.*
Oil on canvas, 32½ x 30 in. (82.5 x 76.2 cm).

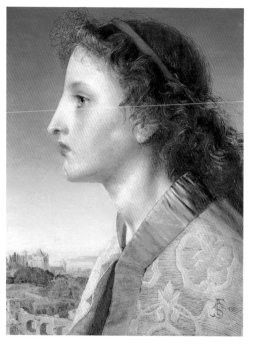

FREDERICK SANDYS (1829–1904).
*Oriana*, 1861.
Oil on panel, 9⅞ x 7½ in. (25.1 x 19 cm).

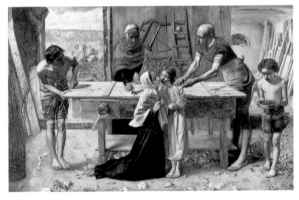

SIR JOHN EVERETT MILLAIS, BT. (1829–1896).
*Christ in the House of His Parents ("The Carpenter's Shop"),*
1849–50. Oil on canvas, 34 x 55 in. (86.4 x 139.7 cm).

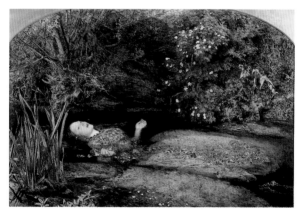

SIR JOHN EVERETT MILLAIS, BT. (1829–1896).
*Ophelia,* 1851–52.
Oil on canvas, 30 x 44 in. (76.2 x 111.8 cm).

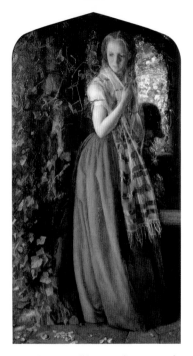

ARTHUR HUGHES (1832–1915).
*April Love*, 1855–56.
Oil on canvas, 35 x 19½ in. (88.9 x 49.5 cm).

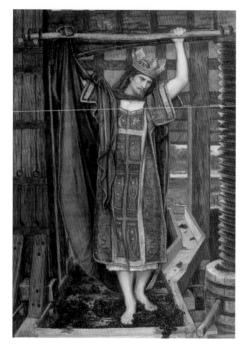

JOHN RODDAM SPENCER STANHOPE (1829–1908).
*The Wine Press,* 1864.
Oil on canvas, 37 x 26¼ in. (94 x 66.7 cm).

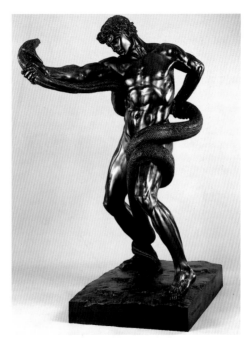

FREDERIC, LORD LEIGHTON (1830–1896).
*An Athlete Wrestling with a Python*, 1877.
Bronze, 68¾ x 38¾ x 43¼ in. (174.6 x 98.4 x 109.9 cm).

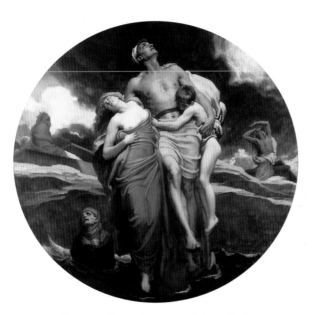

FREDERIC, LORD LEIGHTON (1830–1896).
*And the Sea Gave Up the Dead Which Were in It,*
exhibited 1892. Oil on canvas, diameter: 90 in. (228.6 cm).

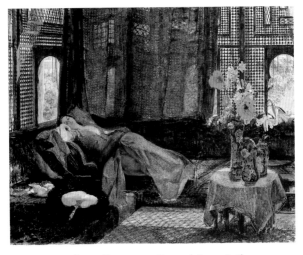

JOHN FREDERICK LEWIS (1805–1876).
*The Siesta,* 1876.
Oil on canvas, 34⅞ x 43¾ in. (88.6 x 111.1 cm).

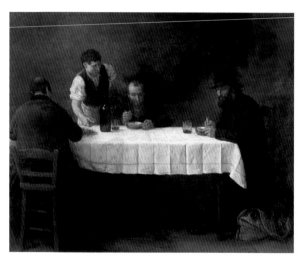

ALPHONSE LEGROS (1837–1911).
*Le Repas des Pauvres*, 1877.
Oil on canvas, 44½ x 56¼ in. (113 x 142.9 cm).

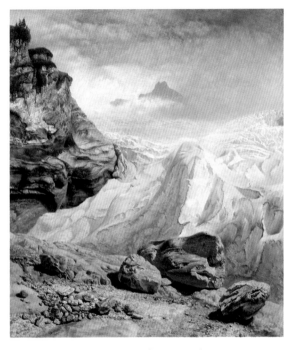

JOHN BRETT (1830–1902).
*Glacier of Rosenlaui*, 1856.
Oil on canvas, 17½ x 16½ in. (44.5 x 41.9 cm).

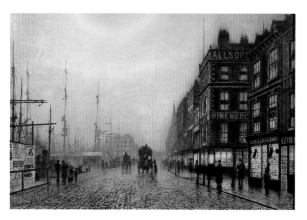

ATKINSON GRIMSHAW (1836–1893).
*Liverpool Quay by Moonlight,* 1887.
Oil on canvas, 24 x 36 in. (61 x 91.4 cm).

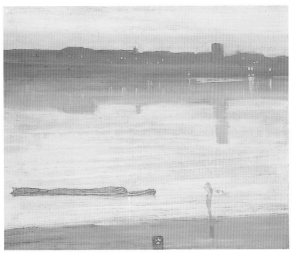

JAMES ABBOTT McNEILL WHISTLER (1834–1903).
*Nocturne in Blue-Green,* 1871.
Oil on panel, 19¾ x 23¼ in. (50.2 x 60.8 cm).

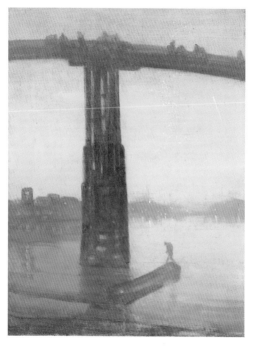

JAMES ABBOTT MCNEILL WHISTLER (1834–1903).
*Nocturne in Blue and Gold: Old Battersea Bridge,* c. 1872–75.
Oil on canvas, 26¾ x 20 in. (68.3 x 51.2 cm).

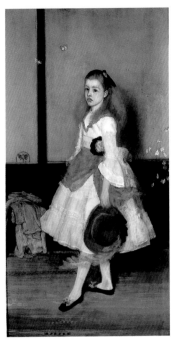

JAMES ABBOTT McNEILL WHISTLER (1834–1903).
*Miss Cicely Alexander: Harmony in Grey and Green*, 1872.
Oil on canvas, 74¾ x 38½ in. (190.2 x 97.8 cm).

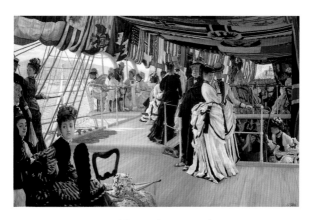

JAMES TISSOT (1836–1902).
*The Ball on Shipboard*, c. 1874.
Oil on canvas, 33⅛ x 51 in. (84.1 x 129.5 cm).

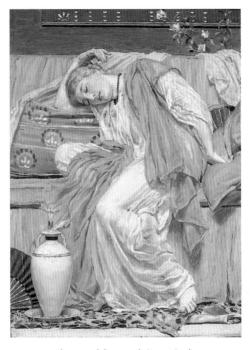

ALBERT MOORE (1841–1893).
*A Sleeping Girl*, c. 1875.
Oil on canvas, 12⅛ x 8⅞ in. (30.8 x 22.5 cm).

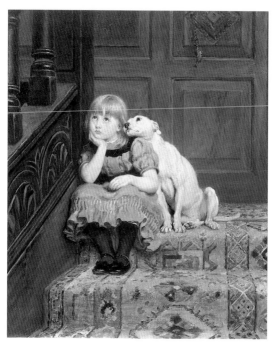

BRITON RIVIERE (1840–1920).
*Sympathy*, c. 1878.
Oil on canvas, 17¾ x 14¾ in. (45.1 x 37.5 cm).

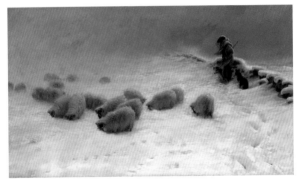

JOSEPH FARQUHARSON (1847–1935).
*The Joyless Winter Day,* exhibited 1883.
Oil on canvas, 41 x 71 in. (104.1 x 180.3 cm).

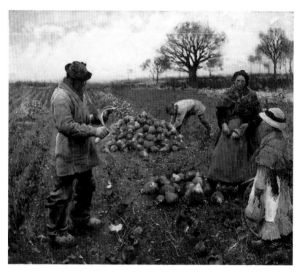

SIR GEORGE CLAUSEN (1852–1944).
*Winter Work,* 1883–84.
Oil on canvas, 30½ x 36¼ in. (77.5 x 92.1 cm).

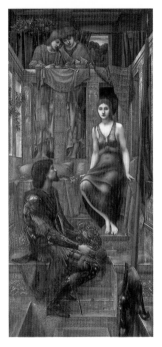

SIR EDWARD COLEY BURNE-JONES, BT. (1833–1898).
*King Cophetua and the Beggar Maid*, 1884.
Oil on canvas, 115½ x 53½ in. (293.4 x 135.9 cm).

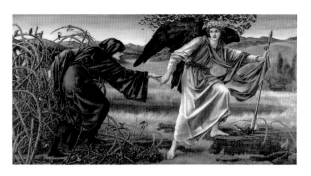

SIR EDWARD COLEY BURNE-JONES, BT. (1833–1898).
*Love and the Pilgrim,* 1896–97.
Oil on canvas, 62 x 120 in. (157.5 x 304.8 cm).

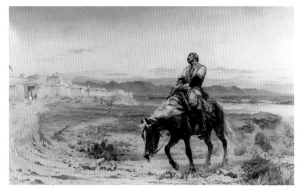

LADY ELIZABETH BUTLER (1846–1933).
*The Remnants of an Army,* 1879.
Oil on canvas, 52 x 92 in. (132.1 x 233.7 cm).

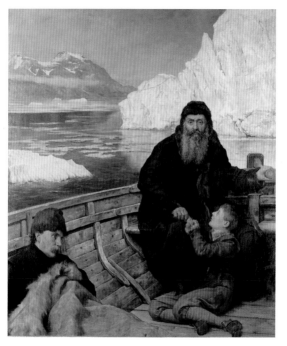

THE HON. JOHN COLLIER (1850–1934).
*The Last Voyage of Henry Hudson*, exhibited 1881.
Oil on canvas, 84¼ x 72¼ in. (214 x 183.5 cm).

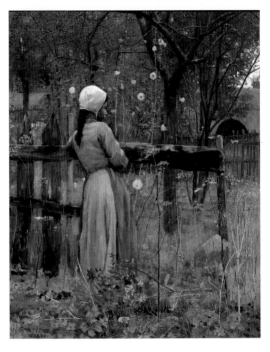

WILLIAM STOTT (1857–1900).
*Girl in a Meadow*, 1880.
Oil on canvas, 28¼ x 22¾ in. (71.8 x 57.8 cm).

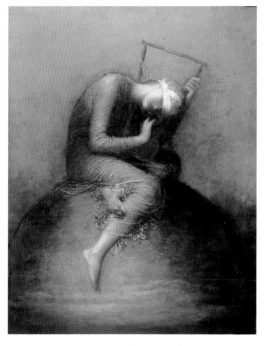

GEORGE FREDERIC WATTS (1817–1904) WITH ASSISTANTS.
*Hope,* 1886.
Oil on canvas, 56 x 44 in. (142.2 x 111.8 cm).

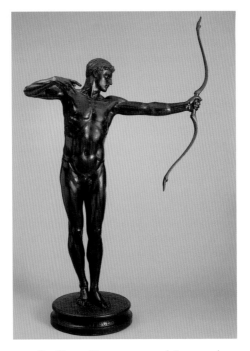

SIR HAMO THORNYCROFT (1850–1925).
*Teucer*, 1881.
Bronze, 94¾ x 59½ x 26 in. (240.7 x 151.1 x 66 cm).

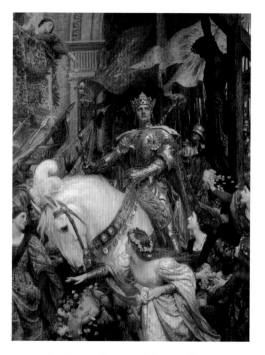

SIR FRANK DICKSEE (1853–1928).
*The Two Crowns,* 1900.
Oil on canvas, 91 x 72½ in. (231.1 x 184.2 cm).

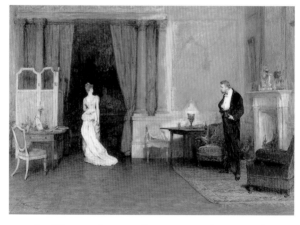

SIR WILLIAM QUILLER ORCHARDSON (1832–1910).
*The First Cloud,* 1887.
Oil on canvas, 32¾ x 47¾ in. (83.2 x 121.3 cm).

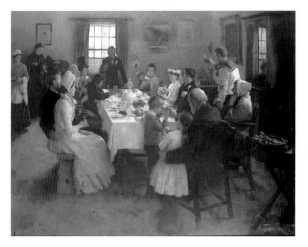

STANHOPE ALEXANDER FORBES (1837–1947).
*The Health of the Bride*, 1889.
Oil on canvas, 60 x 78¾ in. (152.4 x 200 cm).

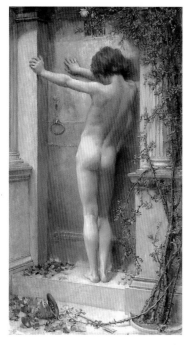

ANNA LEA MERRITT (1844–1930).
*Love Locked Out,* 1889.
Oil on canvas, 45½ x 25¼ in. (115.6 x 64.1 cm).

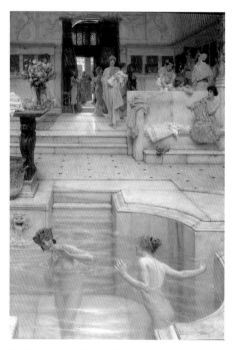

Sir Lawrence Alma-Tadema (1836–1912).
*A Favourite Custom,* 1909.
Oil on panel, 26 x 17¾ in. (66 x 45.1 cm).

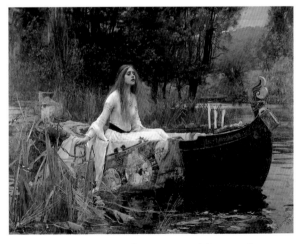

JOHN WILLIAM WATERHOUSE (1849–1917).
*The Lady of Shalott*, 1888.
Oil on canvas, 60¼ x 78¾ in. (153 x 200 cm).

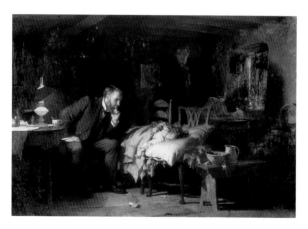

SIR LUKE FILDES (1843–1927).
*The Doctor,* exhibited 1891.
Oil on canvas, 65½ x 95¼ in. (166.4 x 241.9 cm).

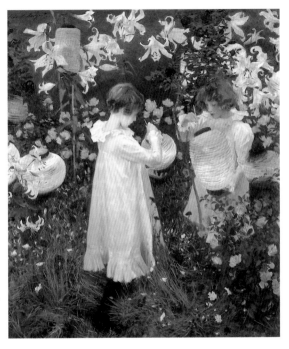

John Singer Sargent (1856–1925).
*Carnation, Lily, Lily, Rose,* 1885–86.
Oil on canvas, 68½ x 60½ in. (174 x 153.7 cm).

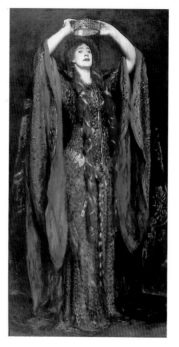

JOHN SINGER SARGENT (1856–1925).
*Ellen Terry as Lady Macbeth,* 1889.
Oil on canvas, 87 x 45 in. (221 x 114.3 cm).

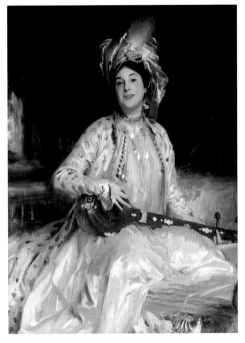

JOHN SINGER SARGENT (1856–1925).
*Almina, Daughter of Asher Wertheimer*, 1908.
Oil on canvas, 52¾ x 39¾ in. (134 x 101 cm).

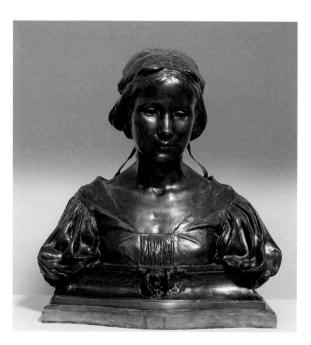

ALFRED DRURY (1856–1944).
*Griselda,* 1896.
Bronze, 21 x 19 x 10 in. (53.3 x 48.3 x 25.4 cm).

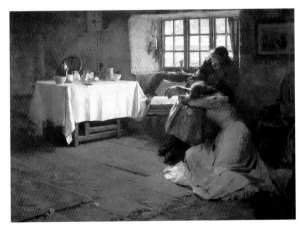

FRANK BRAMLEY (1857–1915).
*A Hopeless Dawn,* 1888.
Oil on canvas, 48¼ x 66 in. (122.6 x 167.6 cm).

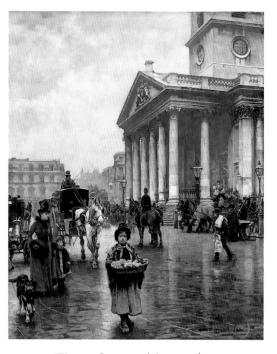

WILLIAM LOGSDAIL (1859–1944).
*St. Martin-in-the-Fields,* 1888.
Oil on canvas, 56½ x 46½ in. (143.5 x 118.1 cm).

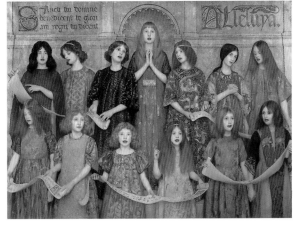

THOMAS COOPER GOTCH (1854–1931).
*Alleluia,* exhibited 1896.
Oil on canvas, 52½ x 72½ in. (133.3 x 184.1 cm).

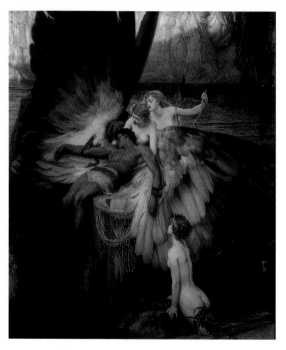

HERBERT DRAPER (1863–1920).
*The Lament for Icarus,* exhibited 1898.
Oil on canvas, 72 x 61¼ in. (182.9 x 155.6 cm).

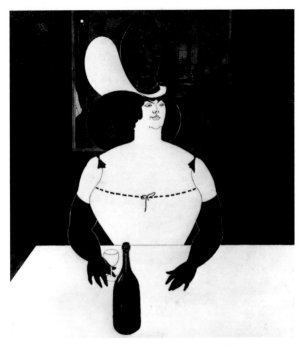

AUBREY BEARDSLEY (1872–1898).
*The Fat Woman,* 1894.
Pen and ink wash on paper, 7 x 6⅜ in. (17.8 x 16.2 cm).

AUBREY BEARDSLEY (1872–1898).
*Messalina and Her Companion,* 1895. Pencil and ink and
watercolour on paper, 11 x 7 in. (27.9 x 17.8 cm).

PHILIP WILSON STEER (1860–1942).
*Boulogne Sands,* 1888–91.
Oil on canvas, 24 x 30⅛ in. (61 x 76.5 cm).

RODERIC O'CONOR (1860–1940).
*Yellow Landscape,* 1892.
Oil on canvas, 26⅝ x 36⅛ in. (67.6 x 91.8 cm).

# THE TWENTIETH CENTURY

The avant-garde in Britain in the early twentieth century was largely sparked by Continental art. Walter Richard Sickert, Whistler's pupil and a friend of Edgar Degas, was instrumental in the 1890s and afterwards in passing on to a slightly younger generation of artists new developments in French painting, which in that period were still little known in Britain. In 1911, with Spencer Gore, Harold Gilman, Charles Ginner, and Robert Bevan, he formed the Camden Town Group. Influenced by Continental Post-Impressionism, they painted urban landscapes and scenes of everyday and often shabby London life.

In 1910 and 1912 the theorist and painter Roger Fry staged two exhibitions that brought the work of Edouard Manet, Paul Cézanne, Henri Matisse, and Pablo Picasso to a London audience for the first time. There was a sudden flowering in London of avant-garde art, which took in the Post-Impressionist realism of the Camden Town Group, the Cézanne-inspired painting and decorative work of the Bloomsbury artists Duncan Grant and Vanessa Bell, the sculpture of Jacob Epstein, and the abstract Vorticist pictures of Wyndham Lewis and David Bomberg. Bomberg's *The Mud Bath* (opposite and page 236) was based on twisting human forms, but

the design has been fragmented and geometricised almost into abstraction. Bomberg wrote that in such works "I appeal to a sense of form. . . . I completely abandon Naturalism and Tradition. I am searching for an Interior expression." It was just such a search for an "interior expression" that was to characterise much of the most exceptional modernist art to be produced in subsequent decades of the twentieth century.

The First World War marked the demise of this cathartic period, and it seemed to represent in physical form the passing of the old order that Lewis, Bomberg, and others had foreseen. After the war's end there was, for a time, a return to a slightly safer, figurative-based art. Stanley Spencer was a leading exponent of this idiom from the 1920s onwards, developing a distinctive style that combined carefully observed detail with a personal vision of modern life infused with his religious beliefs (pages 250–51).

The early 1930s saw the birth of more austerely modernist and abstract art, created primarily among the group of young artists led by Ben Nicholson, Barbara Hepworth, and Henry Moore. They took over the conservative Seven and Five Society, turning it into a spearhead of the avant-garde, and cultivated links with abstract artists in Paris. Nicholson and Hepworth spent most of the Second World War in St. Ives in Cornwall. After the war and

throughout the 1950s a community of abstract artists grew up there, devoted to nonfigurative art and to the expressive potential of abstract colour and paint surface.

In the late 1950s and the 1960s in London an original form of Pop art was developed by Richard Hamilton, Eduardo Paolozzi, and Peter Blake, who felt a passion for popular culture, especially advertising and pop music. A new generation of sculptors moved away from the type of carved work of Hepworth and Moore, which by now was comfortably mainstream. In the early 1960s Anthony Caro constructed abstract sculpture from painted steel (page 290); slightly later, others turned to a variety of new materials not previously associated with sculpture, such as fibreglass and plastics.

From the 1970s up to the present day, Conceptual pieces and installations have been an important aspect of avant-garde British art, whose exponents have turned away from traditional materials and idioms to express their ideas in diverse objects and media. Recent decades have also seen continued admiration for the British figurative tradition as exemplified by the "School of London" painters Francis Bacon, Lucian Freud, Frank Auerbach, R. B. Kitaj, and Leon Kossoff. These painters have taken inspiration from their surroundings in London, although in their work many of them are devoted primarily to the figure or the emotive possibilities of paint.

Much of the work produced in the 1980s by younger artists focused on issues of politics and national identity, partly caused by a government that abandoned the post-war consensus in favour of confrontation. Made from objects he found in London, Tony Cragg's *Britain Seen from the North* (page 303) was created out of the sense of estrangement he felt after returning from abroad to a Britain beset by internal strife and economic problems. Richard Hamilton's *The Citizen* (page 301) depicts an Irish nationalist prisoner during the H-block hunger strikes.

Richard Long is the final artist represented in this book. With his installations of materials taken from the landscape, such as *Norfolk Flint Circle* (page 312), he creates works of art from the very substance of Britain itself, and in doing so he seems to have added a profound and innovative dimension to the lengthy British tradition of poetic naturalism.

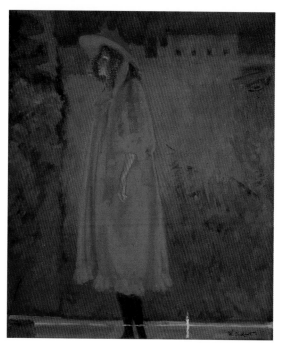

WALTER RICHARD SICKERT (1860–1942).
*Minnie Cunningham at the Old Bedford*, 1892.
Oil on canvas, 30⅛ x 25⅛ in. (76.5 x 63.8 cm).

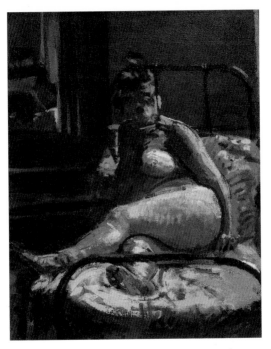

WALTER RICHARD SICKERT (1860–1942).
*La Hollandaise,* c. 1906.
Oil on canvas, 20⅛ x 16 in. (51.1 x 40.6 cm).

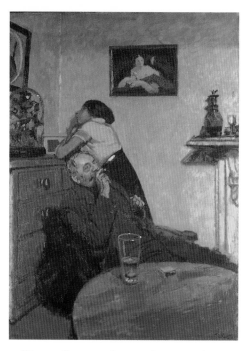

WALTER RICHARD SICKERT (1860–1942).
*Ennui*, c. 1914.
Oil on canvas, 60 x 44¼ in. (152.4 x 112.4 cm).

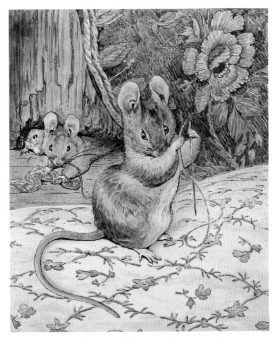

HELEN BEATRIX POTTER (1866–1943).
*The Mice at Work: Threading the Needle, from "The Tailor of Gloucester,"* c. 1902. Pen and ink and watercolour on paper,
4⅜ x 3⅝ in. (11.1 x 9.2 cm).

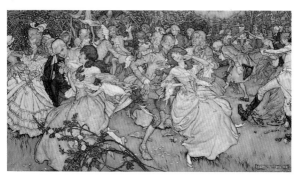

ARTHUR RACKHAM (1867–1939).
*The Dance in Cupid's Alley,* 1904. Pen and ink and watercolour
on paper, 12¾ x 23½ in. (32.4 x 59.7 cm).

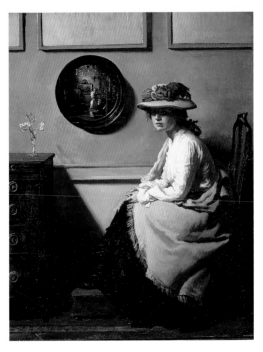

SIR WILLIAM ORPEN (1878–1931).
*The Mirror*, 1900.
Oil on canvas, 20 x 16 in. (50.8 x 40.6 cm).

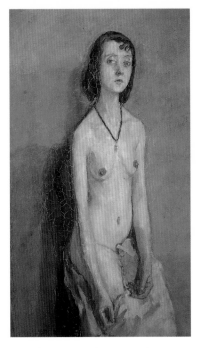

GWEN JOHN (1876–1939).
*Nude Girl,* 1909–10.
Oil on canvas, 17½ x 11 in. (44.5 x 27.9 cm).

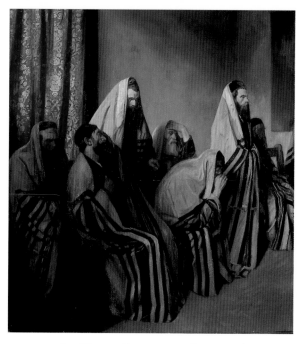

SIR WILLIAM ROTHENSTEIN (1872–1945).
*Jews Mourning in a Synagogue*, 1906.
Oil on canvas, 50 x 39½ in. (127.5 x 115.5 cm).

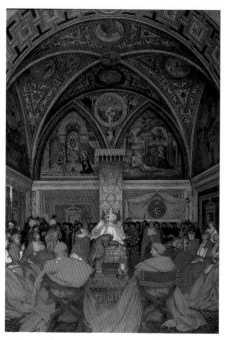

FRANK CADOGAN COWPER (1877–1958).
*Lucretia Borgia Reigns in the Vatican in
the Absence of Pope Alexander VI,* 1908–14.
Oil on canvas, 87 x 60½ in. (221 x 153.7 cm).

WILLIAM STRANG (1859–1921).
*Bank Holiday,* 1912.
Oil on canvas, 60⅛ x 48¼ in. (152.7 x 122.6 cm).

JACK BUTLER YEATS (1871–1957).
*Morning after Rain,* 1912–13.
Oil on canvas, 24 x 36 in. (61 x 91.4 cm).

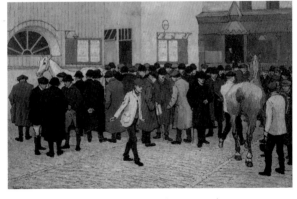

ROBERT BEVAN (1865–1925).
*Horse Sale at the Barbican*, 1912.
Oil on canvas, 31 x 48 in. (78.7 x 121.9 cm).

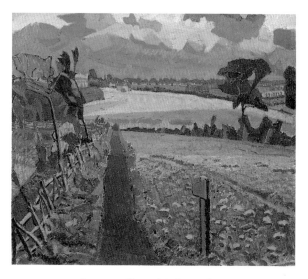

SPENCER GORE (1878–1914).
*The Cinder Path,* 1912.
Oil on canvas, 27 x 31 in. (68.6 x 78.7 cm).

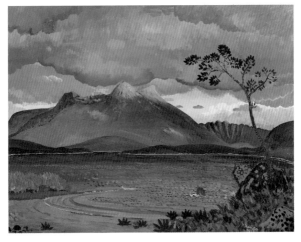

JAMES DICKSON INNES (1887–1914).
*Arenig, North Wales,* 1913.
Oil on panel, 33¾ x 44¾ in. (85.7 x 113.7 cm).

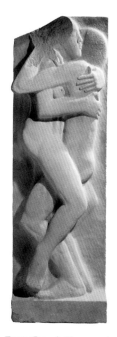

ERIC GILL (1882–1940).
*Ecstasy,* 1910–11.
Portland stone, 54 x 18 x 9 in. (137.2 x 45.7 x 22.8 cm).

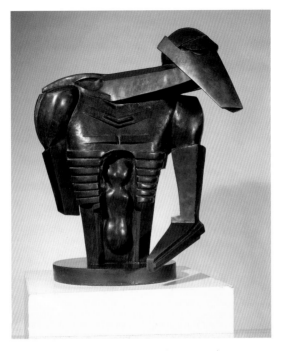

SIR JACOB EPSTEIN (1880–1959).
*Torso in Metal from "The Rock Drill,"* 1913–14.
Bronze, 27¾ x 23 x 17½ in. (70.5 x 58.4 x 44.5 cm).

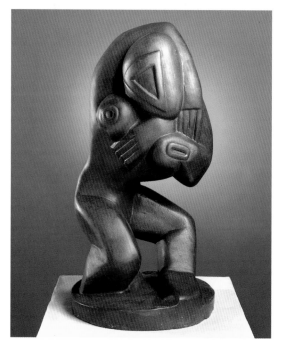

HENRI GAUDIER-BRZESKA (1891–1915).
*Red Stone Dancer,* c. 1913. Red Mansfield stone,
polished and waxed, 17 x 9 x 9 in. (43.2 x 22.9 x 22.9 cm).

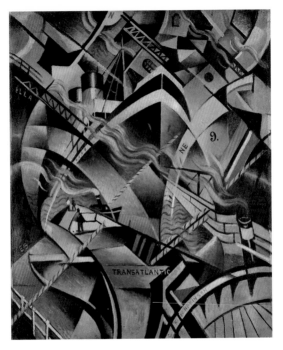

CHRISTOPHER RICHARD WYNNE NEVINSON (1889–1946).
*The Arrival,* c. 1913.
Oil on canvas, 30 x 25 in. (76.2 x 63.5 cm).

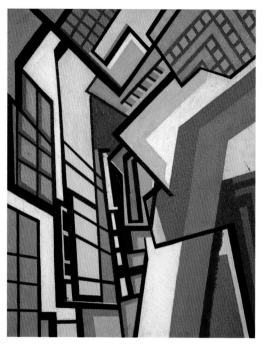

WYNDHAM LEWIS (1882–1957).
*Workshop,* c. 1914–15.
Oil on canvas, 30⅛ x 24 in. (76.5 x 61 cm).

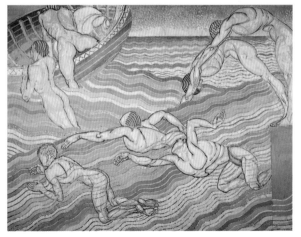

DUNCAN GRANT (1885–1978).
*Bathing,* 1911.
Tempera on canvas, 90 x 120½ in. (228.6 x 306.1 cm).

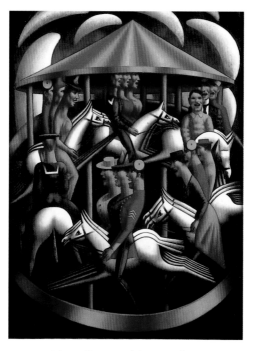

MARK GERTLER (1891–1939).
*Merry-Go-Round*, 1916.
Oil on canvas, 74½ x 56 in. (189.2 x 142.2 cm).

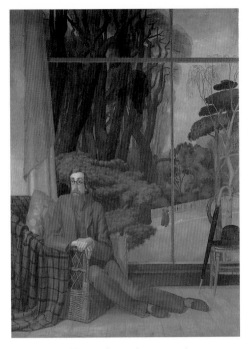

HENRY LAMB (1883–1960).
*Lytton Strachey,* 1914.
Oil on canvas, 96¼ x 70¼ in. (244.5 x 178.4 cm).

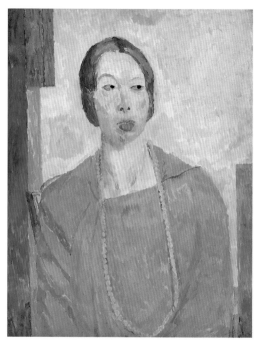

VANESSA BELL (1879–1961).
*Mrs. St. John Hutchinson,* 1915.
Oil on board, 29 x 22¾ in. (73.7 x 57.8 cm).

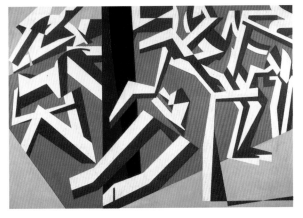

David Bomberg (1890–1957).
*The Mud Bath,* 1914.
Oil on canvas, 60 x 88¼ in. (152.4 x 224.2 cm).

ROGER FRY (1866–1934).
*Essay in Abstract Design,* 1914 or 1915.
Oil and collage on panel, 14¼ x 10⅝ in. (36.2 x 27 cm).

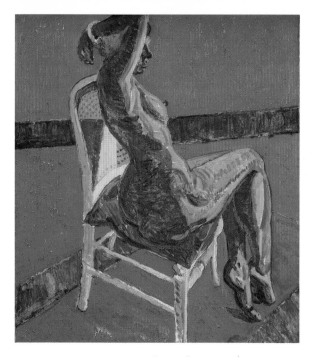

SIR MATTHEW SMITH (1879–1959).
*Nude, Fitzroy Street, No. 1*, 1916.
Oil on canvas, 34 x 30 in. (86.4 x 76.2 cm).

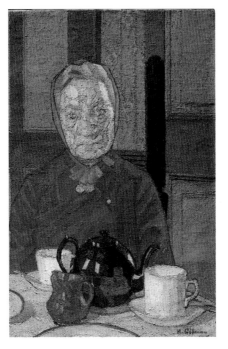

HAROLD GILMAN (1876–1919).
*Mrs. Mounter at the Breakfast Table,* c. 1917.
Oil on canvas, 24 x 16 in. (61 x 40.6 cm).

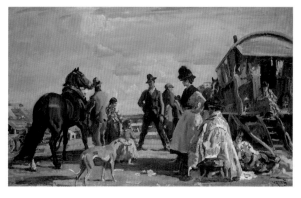

SIR ALFRED MUNNINGS (1878–1959).
*Epsom Downs—City and Suburban Day,* 1919.
Oil on canvas, 31¼ x 50½ in. (79.4 x 128.3 cm).

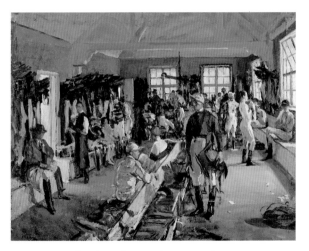

SIR JOHN LAVERY (1856–1941).
*The Jockeys' Dressing Room at Ascot*, 1923.
Oil on canvas, 25 x 32 in. (63.5 x 81.3 cm).

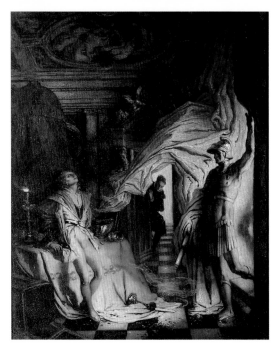

CHARLES RICKETTS (1866–1931).
*Don Juan*, c. 1922.
Oil on canvas, 45¾ x 37¾ in. (116.2 x 95.9 cm).

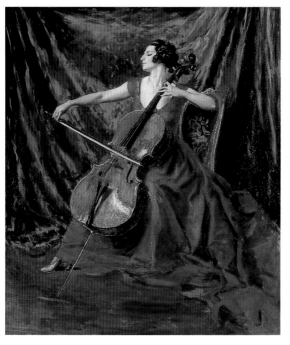

AUGUSTUS JOHN (1878–1961).
*Madame Suggia,* 1920–23.
Oil on canvas, 73½ x 65 in. (186.7 x 165.1 cm).

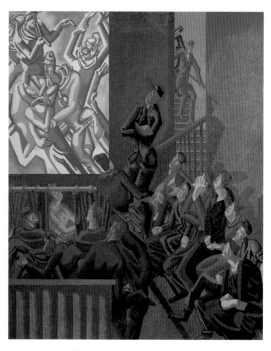

WILLIAM ROBERTS (1895–1980).
*The Cinema,* 1920.
Oil on canvas, 36 x 30 in. (91.4 x 76.2 cm).

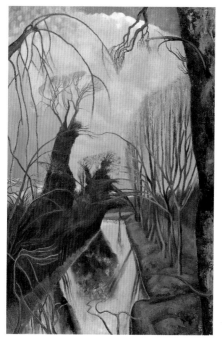

JOHN NASH (1893–1977).
*The Moat, Grange Farm, Kimble,* exhibited 1922.
Oil on canvas, 30 x 20 in. (76.2 x 50.8 cm).

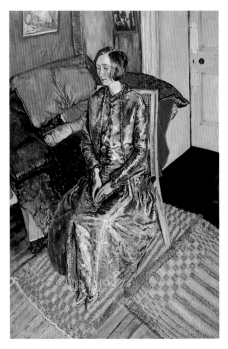

ALVARO GUEVARA (1894–1951).
*Dame Edith Sitwell,* exhibited 1919.
Oil on canvas, 72 x 48 in. (182.9 x 121.9 cm).

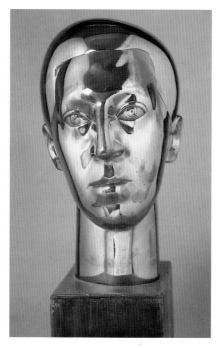

FRANK DOBSON (1888–1963).
*Sir Osbert Sitwell, Bt.,* 1923.
Polished brass, 12½ x 7 x 9 in. (31.8 x 17.8 x 22.9 cm).

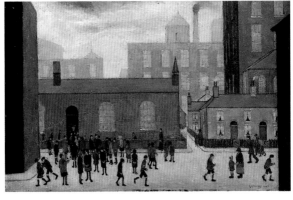

L. S. LOWRY (1887–1976).
*Coming Out of School*, 1927.
Oil on panel, 13½ x 21¼ in. (34.7 x 53.9 cm).

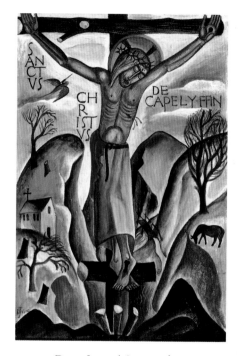

David Jones (1895–1974).
*Sanctus Christus de Capel-y-ffin*, 1925.
Gouache and pencil on paper, 7⅝ x 5¼ in. (19.3 x 13.3 cm).

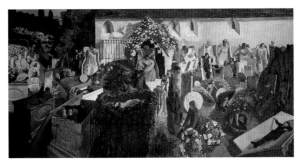

SIR STANLEY SPENCER (1891–1959).
*The Resurrection, Cookham*, 1924–27.
Oil on canvas, 9 x 18 ft. (2.743 x 5.486 m).

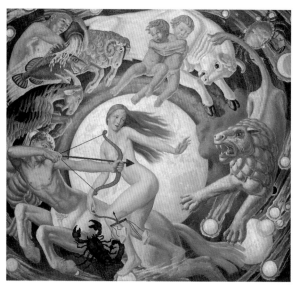

ERNEST PROCTER (1886–1935).
*The Zodiac*, 1925.
Oil on canvas, 60 x 66 in. (152.4 x 167.6 cm).

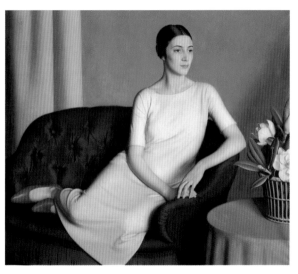

MEREDITH FRAMPTON (1894–1984).
*Marguerite Kelsey*, 1928.
Oil on canvas, 47½ x 55⅝ in. (120.8 x 141.2 cm).

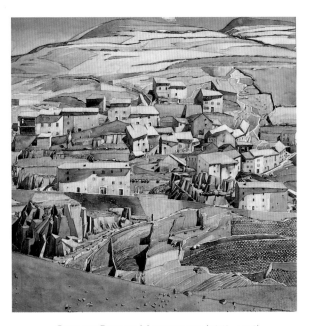

CHARLES RENNIE MACKINTOSH (1868–1928).
*Fetges*, c. 1927.
Watercolour on paper, 18¼ x 18 in. (46.4 x 45.7 cm).

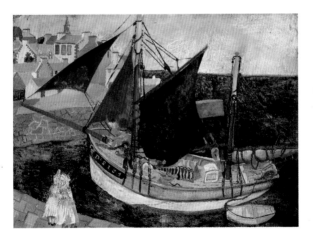

CHRISTOPHER WOOD (1901–1930).
*Boat in Harbour, Brittany,* 1929.
Oil on board, 31¼ x 42¾ in. (79.4 x 108.6 cm).

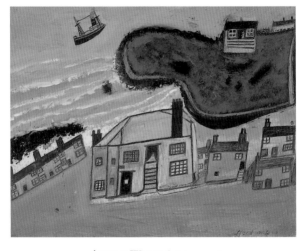

ALFRED WALLIS (1855–1942).
*"The Hold House Port Mear Square Island Port Mear Beach,"*
c. 1932(?). Oil on board, 12 x 15¼ in. (30.5 x 38.7 cm).

PAUL NASH (1889–1946).
*Landscape at Iden,* 1929.
Oil on canvas, 27½ x 35¾ in. (69.8 x 90.8 cm).

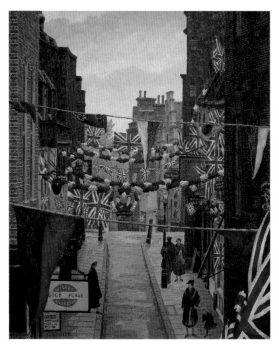

CHARLES GINNER (1878–1952).
*Flask Walk, Hampstead, on Coronation Day,* 1937.
Oil on canvas, 24 x 20 in. (61 x 50.8 cm).

Ivon Hitchens (1893–1979).
*Coronation,* 1937.
Oil on canvas, 35½ x 48 in. (90.2 x 121.9 cm).

SIR WILLIAM NICHOLSON (1872–1949).
*Silver,* 1938.
Oil on panel, 17¼ x 22½ in. (43.8 x 57.1 cm).

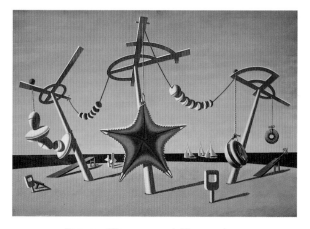

EDWARD WADSWORTH (1889–1949).
*The Beached Margin*, 1937.
Tempera on linen laid on panel, 28 x 40 in. (71.1 x 101.6 cm).

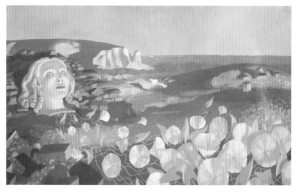

JOHN ARMSTRONG (1893–1973).
*Dreaming Head,* 1938.
Tempera on panel, 18¼ x 30¾ in. (47.8 x 79.4 cm).

EILEEN AGAR (1899–1991).
*Angel of Anarchy,* 1936–40. Fabric and mixed media
over plaster, 20½ x 12½ x 13¼ in. (52 x 31.7 x 33.6 cm).

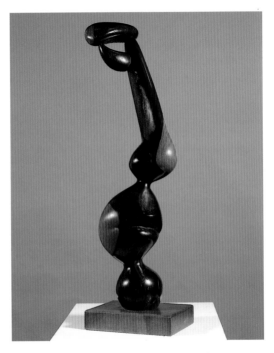

F. E. McWilliam (1909–1992).
*Profile,* 1940.
Lignum vitae, 24½ x 7 in. (62.2 x 17.8 cm).

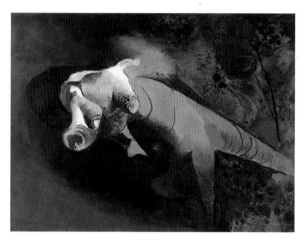

GRAHAM SUTHERLAND, OM (1903–1980).
*Green Tree Form: Interior of Woods,* 1940.
Oil on canvas, 31 x 42½ in. (78.7 x 107.9 cm).

FRANCIS BACON (1909–1992).
*Three Studies for Figures at the Base of a Crucifixion,* c. 1944.
Oil on board, each 37 x 29 in. (94 x 73.7 cm).

CECIL COLLINS (1908–1989).
*The Sleeping Fool,* 1943.
Oil on canvas, 11¾ x 15¾ in. (29.8 x 40 cm).

ROBERT COLQUHOUN (1914–1962).
*Woman with Leaping Cat,* 1945.
Oil on canvas, 30 x 24 in. (76.2 x 61 cm).

HENRY MOORE, OM, CH (1898–1986).
*Pink and Green Sleepers,* 1941. Pen and ink, watercolour,
and gouache on paper, 15 x 22 in. (38.1 x 55.9 cm).

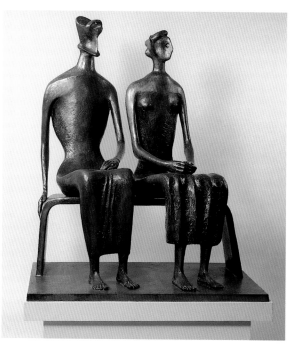

HENRY MOORE, OM, CH (1898–1986).
*King and Queen*, 1952–53, cast 1957.
Bronze, 64½ x 54½ x 33¼ in. (163.8 x 138.4 x 84.5 cm).

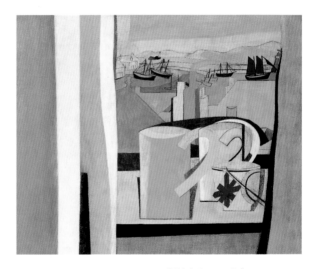

BEN NICHOLSON, OM (1894–1982).
*St. Ives, Cornwall,* 1943–45.
Oil and pencil on canvasboard, 16 x 19¾ in. (40.6 x 50.2 cm).

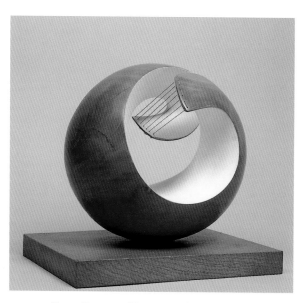

Dame Barbara Hepworth (1903–1975).
*Pelagos,* 1946. Wood, paint, and string,
14½ x 15¼ x 13 in. (36.8 x 38.7 x 33 cm).

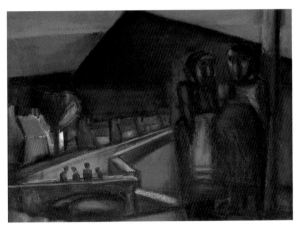

JOSEF HERMAN (born 1911).
*Pregnant Woman and Friend,* 1946. Pastel, pencil, and
watercolour on paper, 25½ x 35¼ in. (64.5 x 89.6 cm).

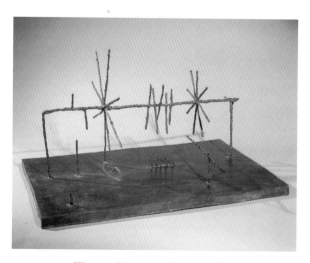

WILLIAM TURNBULL (born 1922).
*Mobile Stabile,* 1949.
Bronze, 15⅛ x 27⅛ x 20 in. (38.4 x 68.9 x 50.8 cm).

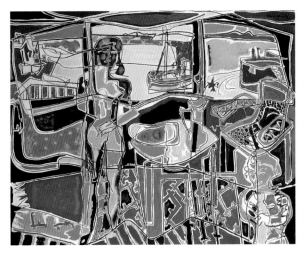

PATRICK HERON (born 1920).
*Harbour Window with Two Figures, St. Ives: July 1950*, 1950.
Oil on board, 60 x 48 in. (121.9 x 152.4 cm).

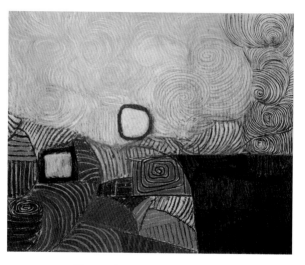

VICTOR PASMORE (born 1908).
*Spiral Motif in Green, Violet, Blue and Gold:*
*The Coast of the Inland Sea,* 1950. Oil on canvas,
32 x 39½ in. (81.3 x 100.3 cm).

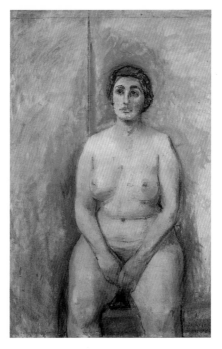

SIR WILLIAM COLDSTREAM (1908–1987).
*Seated Nude*, 1951–52.
Oil on canvas, 42 x 27⅞ in. (106.7 x 70.7 cm).

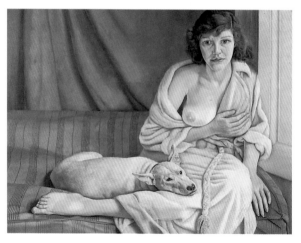

LUCIAN FREUD, OM (born 1922).
*Girl with a White Dog,* 1950–51.
Oil on canvas, 30 x 40 in. (76.2 x 101.6 cm).

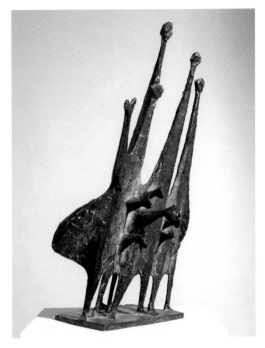

KENNETH ARMITAGE (born 1916).
*People in a Wind*, 1950.
Bronze, 25½ x 15¾ x 13½ in. (64.8 x 40 x 34.3 cm).

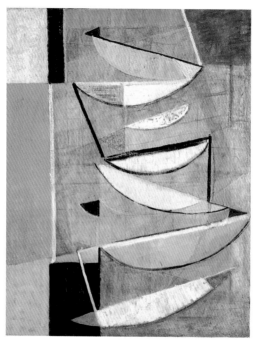

TERRY FROST (born 1915).
*Green, Black and White Movement*, 1951.
Oil on canvas, 43 x 33½ in. (109.2 x 85.1 cm).

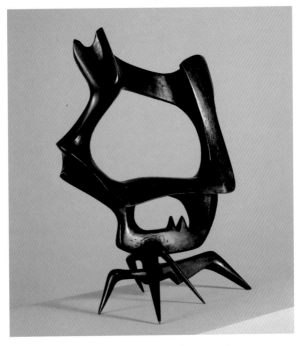

BERNARD MEADOWS (born 1915).
*Black Crab*, 1951–52.
Bronze, 16¾ x 13⅜ x 9½ in. (42.5 x 34 x 24.2 cm).

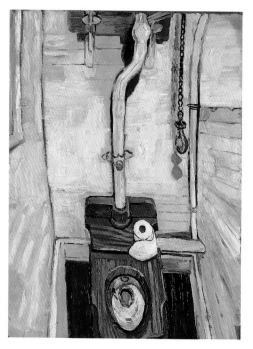

JOHN BRATBY (1928–1992).
*The Toilet*, 1955.
Oil on board, 46⅛ x 34⅜ in. (117.1 x 87.2 cm).

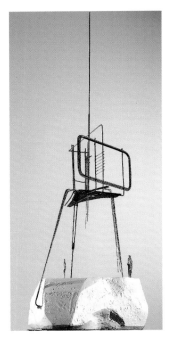

REG BUTLER (1913–1981).
*Working Model for "The Unknown Political Prisoner,"* 1955–56.
Painted steel and bronze with plaster base,
88⅛ x 34⅝ x 33⅝ in. (223.8 x 87.9 x 85.4 cm).

284

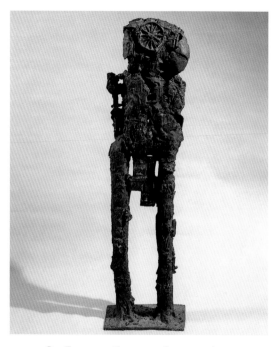

SIR EDUARDO PAOLOZZI (born 1924).
*Cyclops,* 1957.
Bronze, 43¾ x 12 x 8 in. (111.1 x 30.5 x 20.3 cm).

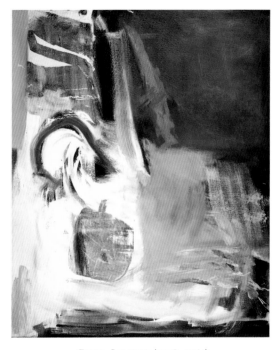

PETER LANYON (1918–1964).
*Thermal,* 1960.
Oil on canvas, 72 x 60 in. (182.9 x 152.4 cm).

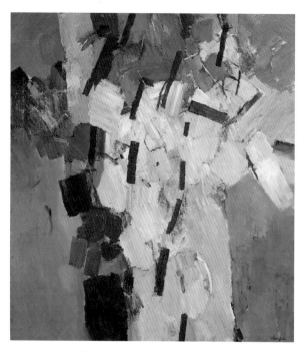

KEITH VAUGHAN (1912–1977).
*Bather: August 4th 1961,* 1961.
Oil on canvas, 40¼ x 36 in. (102.2 x 91.4 cm).

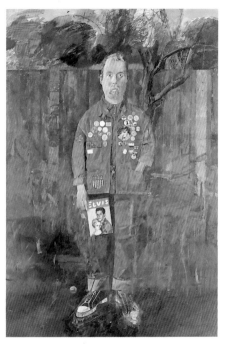

Peter Blake (born 1932).
*Self-Portrait with Badges,* 1961.
Oil on board, 68⅝ x 48 in. (174.3 x 121.9 cm).

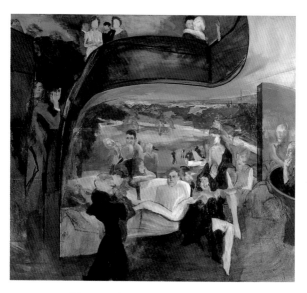

MICHAEL ANDREWS (1928–1995).
*The Deer Park,* 1962.
Oil on panel, 84¼ x 96¼ in. (214 x 244.5 cm).

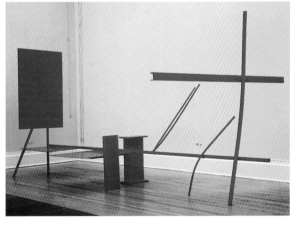

SIR ANTHONY CARO (born 1924).
*Early One Morning,* 1962. Painted steel and aluminium,
9 ft. 6 in. x 20 ft. 4 in. x 11 ft. (2.896 x 6.198 x 3.353 m).

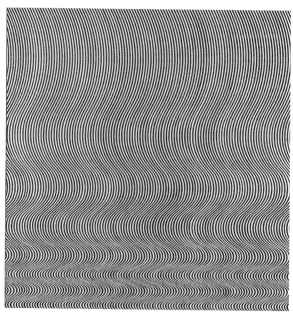

BRIDGET RILEY (born 1931).
*Fall*, 1963.
Emulsion on hardboard, 55½ x 55¼ in. (141 x 140.3 cm).

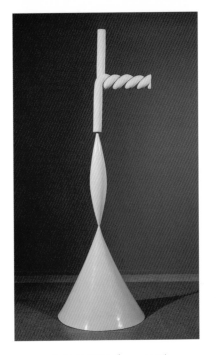

PHILLIP KING (born 1934).
*Tra-La-La,* 1963.
Plastic, 108 x 30 x 30 in. (274.3 x 76.2 x 76.2 cm).

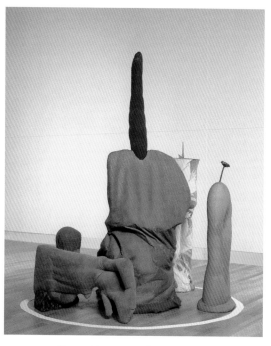

BARRY FLANAGAN (born 1941).
*aaing j gni aa,* 1965. Plaster, cloth, and found objects,
72 x 36 x 36 in. (182.9 x 91.4 x 91.4 cm).

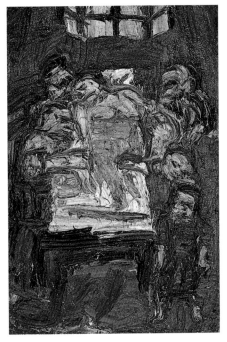

LEON KOSSOFF (born 1926).
*Woman Ill in Bed, Surrounded by Family*, 1965.
Oil on hardboard, 73 x 49 in. (185.4 x 124.5 cm).

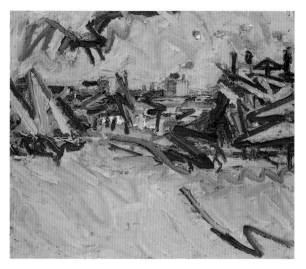

FRANK AUERBACH (born 1931).
*The Origin of the Great Bear,* 1967–68.
Oil on board, 45 x 55⅛ in. (114.3 x 139.7 cm).

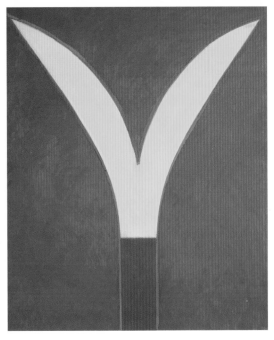

PETER KINLEY (1926–1988).
*Yellow Flower*, 1966–67.
Oil on canvas, 60 x 50¼ in. (152.4 x 127 cm).

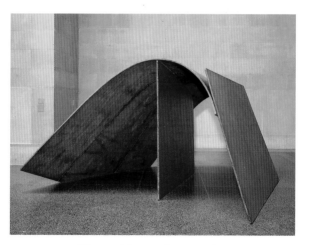

WILLIAM TUCKER (born 1935).
*Tunnel*, 1972–75. Laminated board and steel,
6 ft. 11⅞ in. x 12 ft. 7⅜ in. x 10 ft. 8¾ in.
(2.13 x 3.84 x 3.27 m). 297

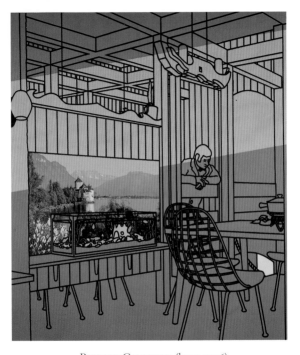

PATRICK CAULFIELD (born 1936).
*After Lunch*, 1975.
Acrylic on canvas, 98 x 84 in. (248.9 x 213.4 cm).

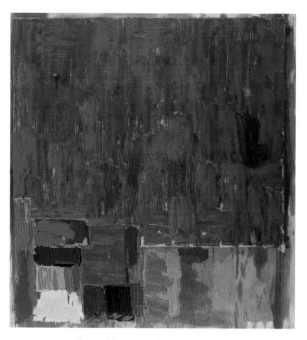

JOHN HOYLAND (born 1934).
*Saracen,* 1977.
Acrylic on canvas, 96 x 90 in. (243.8 x 228.6 cm).

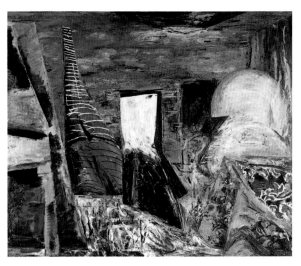

JOHN WALKER (born 1939).
*Labyrinth III,* 1979–80.
Oil and wax on canvas, 100 x 123 in. (245.7 x 298.8 cm).

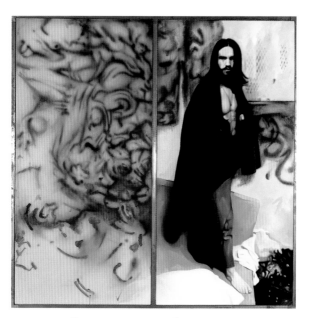

Richard Hamilton (born 1922).
*The Citizen*, 1981–83. Oil on two canvases,
81⅜ x 82¾ in. (206.7 x 210.2 cm), overall.

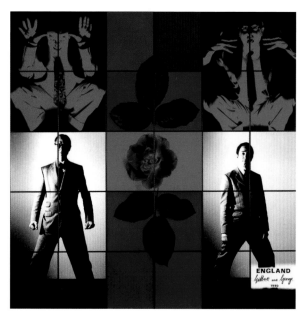

GILBERT AND GEORGE (born 1943 and 1942).
*England,* 1980. Thirty photographs in black frames,
119½ x 119½ in. (302.6 x 302.6 cm), overall.

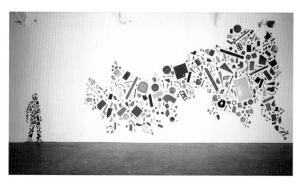

TONY CRAGG (born 1949).
*Britain Seen from the North*, 1981. Plastic and mixed media,
12 ft. 1½ in. x 22 ft. 11 in. and 67 x 23 in.
(3.696 x 6.985 m and 170.2 x 58.4 cm).

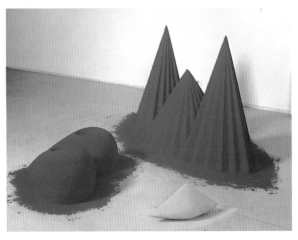

ANISH KAPOOR (born 1954).
*As If to Celebrate, I Discovered a Mountain Blooming
with Red Flowers,* 1981. Wood, cement, polystyrene, and
pigment, three elements: 38¼ x 30 x 63 in., 13 x 28 x 32 in.,
and 8¼ x 6 x 18½ in. (97 x 76.2 x 160 cm, 33 x 71.1 x
81.3 cm, and 21 x 15.3 x 47 cm).

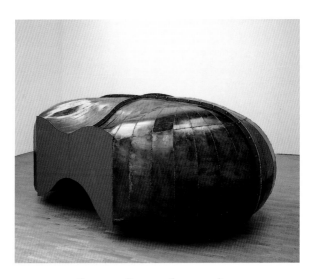

RICHARD DEACON (born 1949).
*For Those Who Have Ears No. 2,* 1983.
Wood and resin,
8 ft. 11½ in. x 13 ft. 1½ in. x 3 ft. 7½ in.
(2.73 x 4 x 1.1 m).

DAVID MACH (born 1956).
*Thinking of England,* 1983. Lacquered glass bottles filled
with water, 7⅞ x 66⅛ x 91¾ in. (20 x 168 x 233 cm).

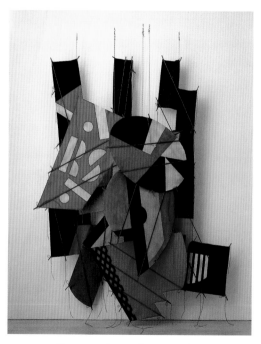

RICHARD SMITH (born 1931).
*The Typographer,* 1986. Acrylic on seven canvas panels
suspended on rods with string, 117 x 79½ x 22½ in.
(297.2 x 202 x 67.3 cm), overall.

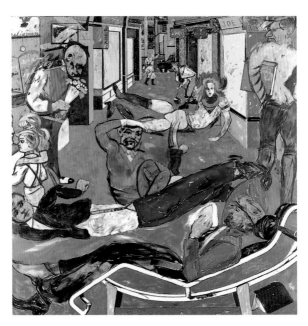

R. B. KITAJ (born 1932).
*Cecil Court, London W.C.2. (The Refugees)*, 1983–84.
Oil on canvas, 72 x 72 in. (183 x 183 cm).

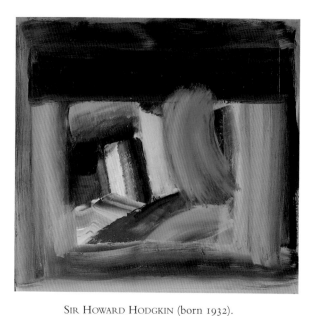

SIR HOWARD HODGKIN (born 1932).
*Rain,* 1984–89.
Oil on panel, 64½ x 70¾ x 2 in. (164 x 179.5 x 5.1 cm).

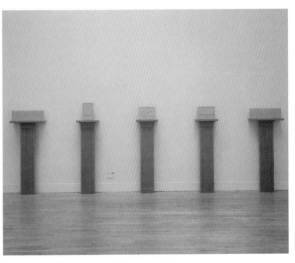

IAN HAMILTON FINLAY (born 1925) WITH JOHN ANDREW.
*A Wartime Garden*, 1989. Twenty-four limestone blocks on
painted fireboard plinths, 5 ft. 3¾ in. x 29 ft. x 29 ft. ⅞ in.
(1.62 x 8.84 x 8.86 m), overall.

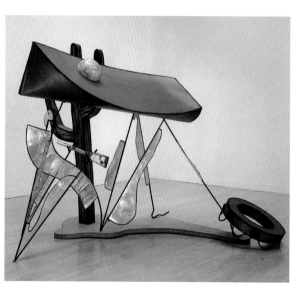

BILL WOODROW (born 1948).
*The Glass Oar,* 1989.
Glass, steel, enamel paint, gold leaf, and varnish,
99¼ x 123¼ x 77½ in. (252 x 313 x 197 cm).

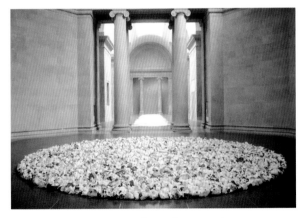

RICHARD LONG (born 1945).
*Norfolk Flint Circle,* 1990.
Norfolk flint pieces, diameter: 26 ft. 3 in. (8 m).

# INDEX OF ILLUSTRATIONS

313

317

Editor: Nancy Grubb · Cover Design: Patrick Seymour
Production Editor: Owen Dugan · Production Manager: Lou Bilka

First hardcover edition

15 14 13 12 11 10 9 8 7 6 5 4 3

For bulk and premium sales and for text adoption procedures, write to Customer Service Manager, Abbeville Press, 137 Varick Street, New York, NY 10013 or call 1-800-ARTBOOK.